DATE			

Discovering
American Folk Art

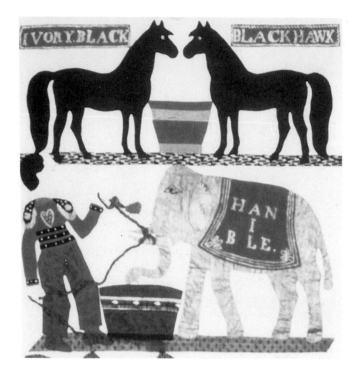

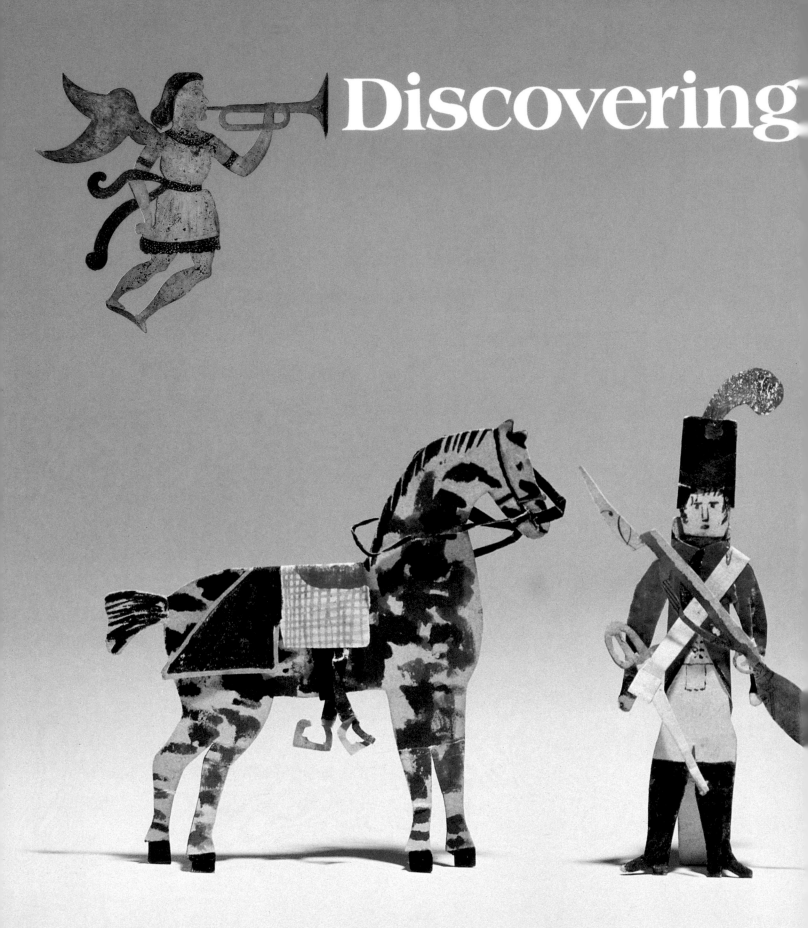

Discovering

American Folk Art

by Cynthia V. A. Schaffner

Folk Art Projects
by Madeline H. Guyon

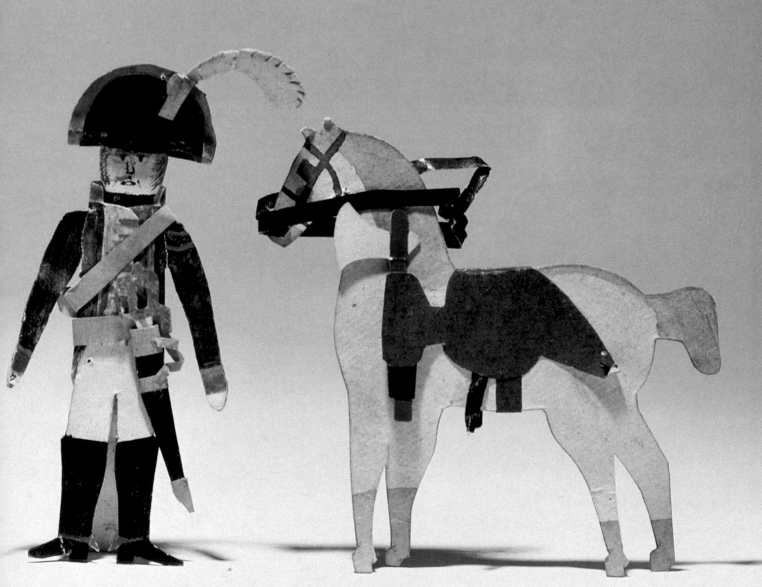

Harry N. Abrams, Inc., Publishers, New York
in association with the
Museum of American Folk Art, New York

For Hilary

EDITORS: Ruth Eisenstein, Ellen Rosefsky
DESIGNER: Darilyn Lowe
PHOTOGRAPHER: George Ross
PATTERNS ILLUSTRATOR: Patrick O'Brien

All the objects illustrated are from the collection of the Museum of American Folk Art, New York.

Library of Congress Cataloging-in-Publication Data

Schaffner, Cynthia V. A.
 Discovering American folk art / by Cynthia V. A. Schaffner. Folk art projects / Madeline H. Guyon.
 p. cm.
 Includes bibliographical references and index.
 ISBN 0–8109–3206–7
 1. Folk art—United States. I. Guyon, Madeline H. Folk art projects. II. Museum of American Folk Art. III. Title.
NK805.S28 1991
745'.0973—dc20 91–8071
 CIP

Published in 1991 by Harry N. Abrams, Incorporated, New York
A Times Mirror Company

page 1:
Bird of Paradise Quilt Top
(detail), see page 11

page 2:
Archangel Gabriel Weather Vane
Artist unknown
Region unknown, c. 1840
Painted sheet metal,
$35 \times 32\frac{1}{2} \times \frac{1}{4}$"
Gift of Mrs. Adele Earnest

pages 2 and 3:
Soldiers and Horses Paper Dolls, see page 49

opposite:
Ruddy Turnstone Decoy
Artist unknown
Region unknown, 1900
Wood, $8\frac{3}{4}$" long
Gift of Alastair B. Martin

Contents

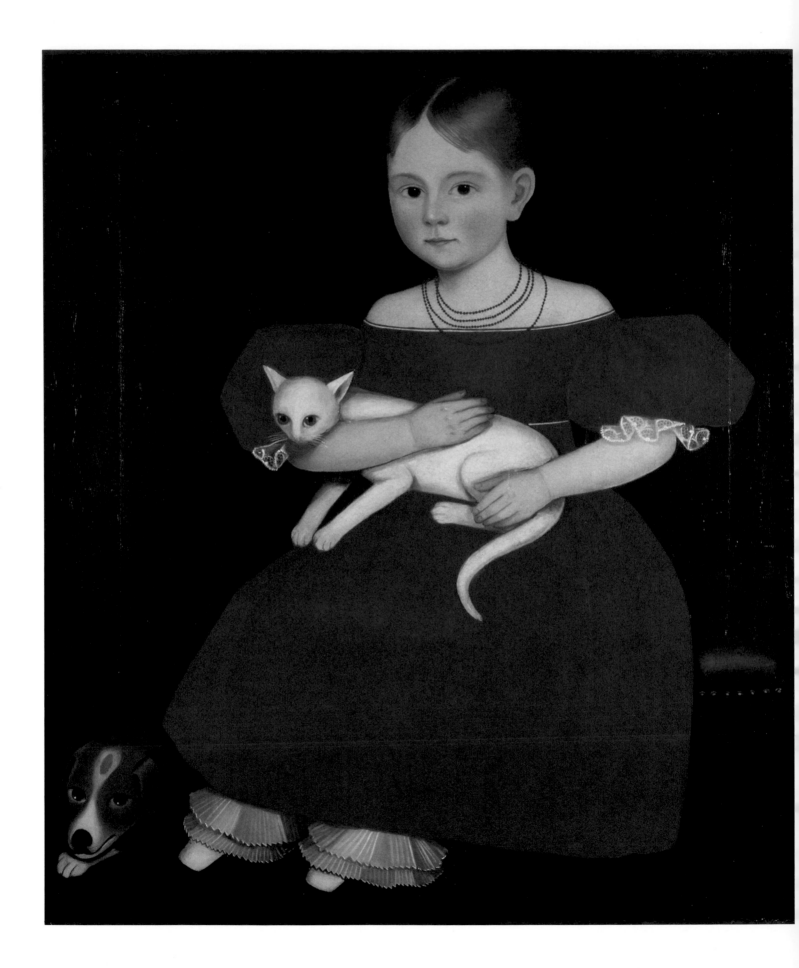

CHAPTER ONE # What Is American Folk Art?

D ISCOVERING AMERICAN FOLK ART takes us back to earlier centuries, when Americans led a more rugged existence, making with their own hands the objects they used in their daily lives. There were few machines and no factories. In those early days, Americans made a wide variety of objects so skillfully created and so imaginatively decorated that they deserve to be ranked as art. These works, most of which were made by people whose names are not known to us, are classified as folk art.

American folk art can be found in many forms, and it has changed and expanded in scope throughout our history. Here is a sampling of the many categories of American folk art represented in the Museum of American Folk Art in New York, many examples of which are illustrated in this book.

Paintings Works of art made with paint, pencil, ink, pastels, watercolor, or chalk applied to a flat surface.

Theorem paintings	Watercolors
Portraits	Frakturs
Landscapes	Silhouettes
Seascapes	Still lifes

Sculpture Three-dimensional objects, usually made of wood, clay, stone, metals, and marble.

Weather vanes	Trade signs
Gravestones	Cigar-store Indians
Whirligigs	Decoys
Ship figureheads	Wood carvings

Textiles Spun or woven fabric decorated with stitching or other handwork.

Quilts	Samplers
Coverlets	Bed linens
Hooked rugs	Wool blankets

Household Objects Handcrafted articles and utensils used in everyday life.

Chairs	Pottery
Tables	Scrimshaw
Clocks	Cookie cutters
Boxes	Toys
Yarn reels	

opposite:
Girl in Red Dress with Cat and Dog
Ammi Phillips (1788–1865)
Vicinity of Amenia, New York, 1834–36
Oil on canvas, 30 × 25″
Promised anonymous gift

FOLK ARTISTS WERE USUALLY SELF-TAUGHT

Most folk artists were not trained as fine artists. They did not go to art schools but taught themselves. Some folk artists developed such skill and artistic sensibility that they are regarded as masters of their craft. In the eighteenth and nineteenth centuries, folk artists created things that were needed and then decorated them to express their own sense of beauty and style. In this century, when most objects used in daily living are readily available, folk artists work in a tradition closer to that of formal art.

WHO WERE THESE FOLK ARTISTS?

A schoolgirl who sewed a sampler to learn the stitches she would need to make the clothes and linens for her family.

A schoolchild who with pen and ink created a calligraphy drawing to practice the script writing required in business.

A farmer who whittled a decoy out of wood to use when hunting to attract ducks and geese.

A sign painter who, for extra income, painted the portrait of a family.

A sailor who carved a pie cutter from a whale bone to pass the time during a long whaling voyage.

A grandmother who recorded her past by painting a scene remembered from her childhood.

A carpenter who carved and painted life-size animals during his slack times.

MOST FOLK ART IS CREATED TO FILL A NEED

Until industrialization, most folk art was created to fill needs: the need to keep warm, to hunt for food, to predict the weather, to carry water, to teach the alphabet, or to give light.

FOLK ART IS HANDMADE

Folk art is not machine-made; the tools involved are wielded by hand. Each object that is made is one of a kind. When we look at American folk art, we see in each object the skill and artistry of the maker and learn something about the time and place in which it was made.

LOOKING AT FOLK ART AS ART

In the language of art the key words are:

LINE COLOR SHAPE TEXTURE PATTERN FORM

Folk art is characterized by emphasis on the use of *color,* simplicity of *line,* and bold, simple *forms.* Folk artists often pay minute attention to details in *patterns* and *textures.*

In folk art, as in any art, it is fascinating to see how the artist uses all these elements to create a composition. In a painting you look to see what colors the artist chooses and how they work together. You examine the shapes and forms and observe how the artist uses and repeats triangular, circular, square, rectangular, and oval shapes within the work. You notice that the artist also creates texture, that is, achieves a smooth or rough effect. You look to see how all these elements are combined into a whole.

LOOKING AT FOLK ART AS HISTORY

Folk art illustrates the history of American life. Many folk art paintings give us information about the architecture, transportation, clothing styles, popular games and toys, and even the spirit of their time. Landscapes and seascapes record a town at a certain stage in its growth and history. On the cover and in Chapter Six you will see New York City in

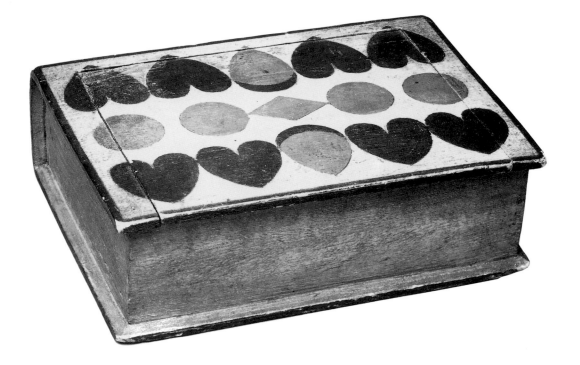

1848 as portrayed by a folk artist. Often a folk art object reveals a very personal story, as in the case of the Bird of Paradise quilt top shown in this chapter.

The objects we know as folk art were often given as gifts and frequently contained messages, verses, poems, or popular sentiments. These help to tell us something of the ideas and customs of the time in which they were made. You will find examples in samplers, valentines, and frakturs as you continue your discovery of American folk art.

When folk art historians and curators study a work, they ask: Who made it? What is it made of? When was it made? Where was it made? Why was it made? Finding the answers to these questions is part of the exciting discovery process, which sometimes takes hours, days, and even years of hard work. The captions accompanying the works of folk art shown here give some answers to these questions; you will see that many questions still remain. And new discoveries are being made all the time.

Looking at folk art as art and as history makes examining these masterpieces of American folk art from the permanent collection of the Museum of American Folk Art more memorable and teaches us something about our past as well.

THE ARTIST OF *GIRL IN RED DRESS WITH CAT AND DOG*

This portrait was painted by Ammi Phillips, a self-taught folk artist who traveled throughout the East Coast, painting likenesses of people (see page 6). He was active during the first half of the nineteenth century; photography, invented in 1839, was not yet in general use. He was a very popular artist, painting more than five hundred portraits as he traveled from community to community.

Ammi Phillips made his living by painting portraits, and the more of them he painted the more money he earned. To speed up the process, he devised a formula pose, against a plain dark background, that he could adapt to most of his subjects. To the likeness of the sitter he would add individual touches in the form of jewelry, furniture, pets, toys, books, or other personal belongings. He often repeated these elements. There are three known paintings by Phillips of a girl in a red dress with a dog underfoot. This is the only one in which Phillips added a white cat. The dog appears in many of his portraits dating from this period.

Painted Box
Artist unknown
Pennsylvania, c. 1835
Painted wood,
$1\frac{3}{4} \times 5\frac{1}{4} \times 3\frac{5}{8}$"
Bequest of Samuel S. Meulendyke

LOOKING AT *GIRL IN RED DRESS WITH CAT AND DOG* AS ART

Being self-taught, Ammi Phillips had to find his own solutions to his painting problems. He was a master of using contrasting bold colors, and his faces glow with a warm serenity and beauty. In this portrait there are special details, such as the strands of coral beads that soften the expanse of neck and shoulders. In the eighteenth century, coral beads were believed to ward off illness.

Phillips's masterly use of contrast adds much to the charm of this painting. How well the white cat is defined against the bright red dress. How sharply the child's red dress stands out against the plain black background. The graceful line of the child's neck leads the viewer's eye to the billowing sleeves, and the repeated curves continue as her slim waist meets the fullness of the skirt. This portrait is a beautiful and pleasing composition, and one of the great works of American folk art.

LOOKING AT THE BIRD OF PARADISE QUILT TOP AS HISTORY

Traditionally, girls in America began making quilts almost as soon as they learned to sew, and usually by the time they were married they had made thirteen quilts. In many communities it was the custom that the thirteenth quilt became the bridal quilt, the most beautiful and intricate of all.

Fortunately, this Bird of Paradise quilt top can be dated. It was given to the Museum together with the newsprint and paper templates, or patterns, used to form the beautiful birds, flowers, people, and animals that decorate it, and the dates on the newspapers tells us that the quilt was probably made about 1860. The templates also tell us something about the history of the quilt and its maker.

In the paper templates you can see a man and a woman, the bridegroom and the bride. Now look carefully at the quilt. You will find the woman in the top right-hand box in the center of the quilt, but there is no man in the square next to her or anywhere in the quilt. White roses are sewed into the square where we would expect to find the bridegroom. The curators at the Museum of American Folk Art believe that the man may have died fighting in the Civil War (1861–65) and that this quilt top may have been made in anticipation of a wedding that never took place. After stitching the white roses into the square in memory of her fiancé, the maker folded the quilt top and never finished it. This beautiful and historic quilt is all the more memorable because of the touching personal story it reveals.

The early photograph (see page 13)—a daguerreotype—is believed to be a picture of the maker of the quilt. It was found in the attic in which the quilt was stored. Another piece of evidence is that the hairstyle in the two representations, the quilt and the photograph, is similar. But who the woman was remains unknown.

∽ If you study the designs in this quilt for a few minutes, you will understand why the quilt has been named the Bird of Paradise. The many pairs of birds and animals in the quilt are symbols of courtship and marriage. Notice the horses—Ivory Black, Black Hawk, Flying Cloud, and Eclipse—popular nineteenth-century racehorses. Also try to find Han i ble, the elephant.

Enjoy your journey of discovery as you wander through the chapters of this book. You will see many beautiful works of folk art from the collection of the Museum of American Folk Art. Then, following the suggestions in the section Folk Art Projects (pp. 69–93), you can try your hand at creating objects that will heighten your appreciation of the skill and artistic workmanship that went into creating America's folk art.

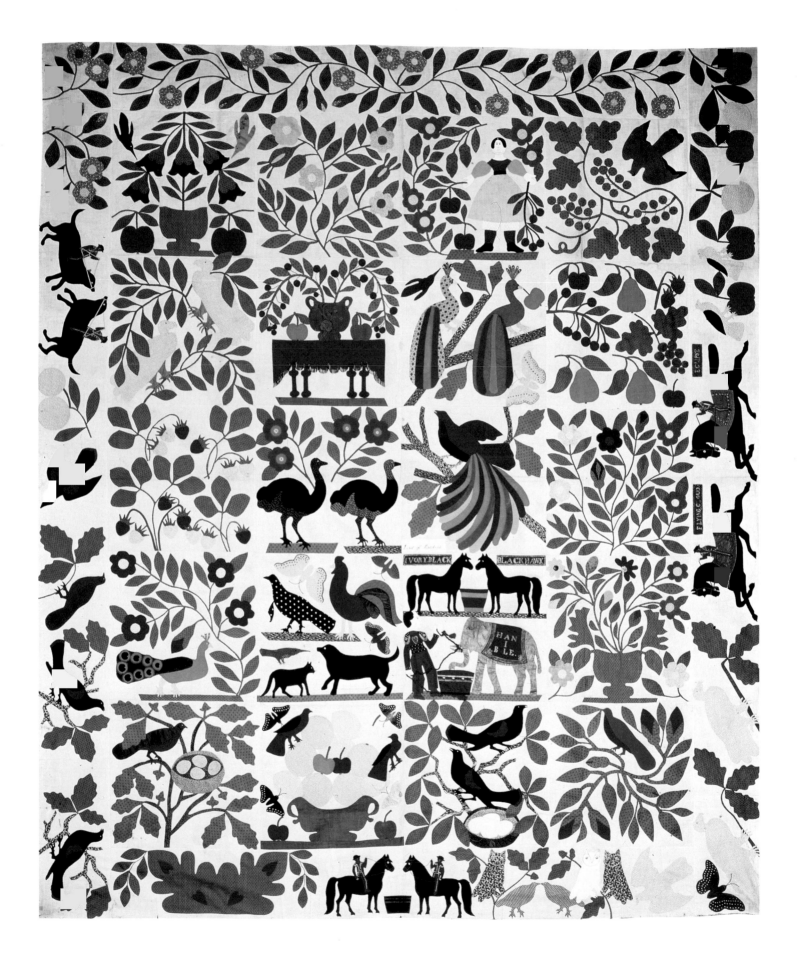

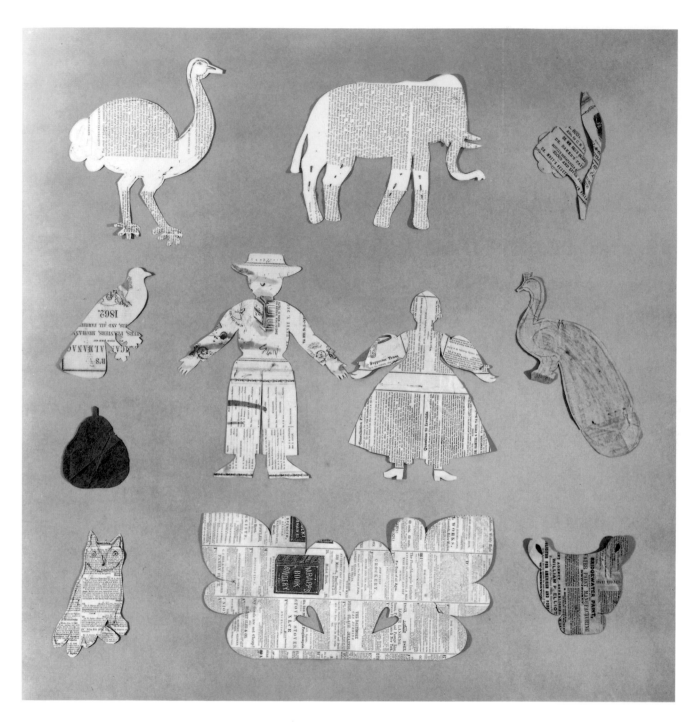

**Patterns for Bird of
Paradise Quilt Top**
Artist unknown
Vicinity of Albany,
1853–63
Cut and pinned newspaper
and paper
Bride: 10⅛ × 7″
Bridegroom: 10¾ × 8″
Elephant: 7⅜ × 9⅜″
Gift of the Trustees of the
Museum of American Folk
Art

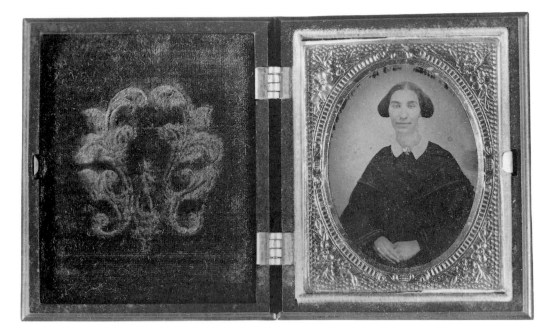

Portrait of a Woman
Photographer unknown
Vicinity of Albany,
1858–63
Daguerreotype, 1¾ × 1⅜″
(sight)
Gift of the Trustees of the
Museum of American Folk
Art

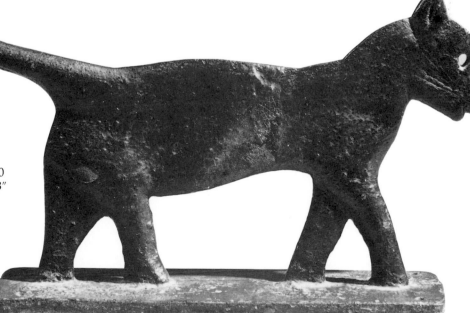

Cat Bootscraper
Artist unknown
Region unknown, c. 1900
Cast iron, 11⅜ × 17½ × 3″
Gift of the Friends
Committee

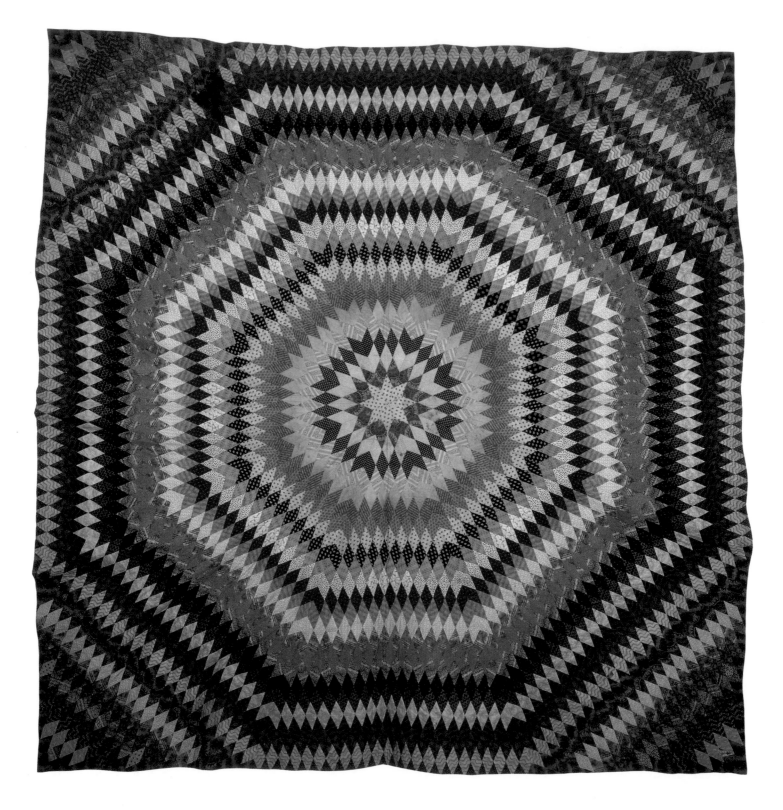

Keeping Warm

Announced by all the trumpets of the sky,
Arrives the snow, and, driving o'er the fields,
Seems nowhere to alight: the whited air
Hides hills and woods, the river, and the heaven,
And veils the farm-house at the garden's end.
The sled and traveller stopped, the courier's feet
Delayed, all friends shut out, the housemates sit
Around the radiant fireplace, enclosed
In a tumultuous privacy of storm.

—Ralph Waldo Emerson (1803–1882), "The Snow-Storm"

UNTIL THE 1830S, MOST HOUSES were heated only by fireplaces. It is hard to imagine how cold it must have been indoors during northern winters. Diaries of the time tell of waking up in the morning to find ice in the washbowl and of having the ink freeze in the inkwell on a cold winter evening. Being snowbound for weeks on end was a reality of New England winters.

Many routines of daily life centered on preparing for winter. After the fall harvest, barns were bulging with bales of sweet-smelling hay and the corn cribs were full; these supplies would provide for the animals on the farm. The shelves in the kitchen were stocked with jars of preserved fruits and vegetables and jams and jellies. The cool, dark root cellar contained bins of onions, potatoes, garlic, carrots, turnips, and other root vegetables. The woodshed was piled high with enough firewood to stoke the fireplaces and the cooking stoves through the winter.

Once winter arrived, homemade woolen socks, caps, sweaters and homespun wool coats and fur hats helped keep the family warm during the day. At night they braved the cold bedchambers with the aid of featherbeds and layers of patchwork quilts, piled on top of the homespun linen sheets.

WHAT IS A QUILT?

A quilt is a warm bedcover. A "cloth sandwich," it is made up of a patterned top, a filler of cotton or wool batting, and a back of plain fabric. The three layers are held together by small stitches in an overall design.

Quilt tops, with their beautiful designs, are the focus of our attention here. There are three kinds of quilt tops:

1. Pieced Quilt Tops are made of cut fabric pieces stitched together end-to-end to form quilt blocks, which are then stitched together to form an overall pattern. Most pieced quilt tops feature geometric shapes that are repeated over and over.

2. Appliquéd Quilt Tops are made of forms cut from one fabric and stitched down on another fabric with a fine hemming or buttonhole stitch. Most appliquéd quilt tops have designs with curved edges: flowers, birds, animals, wreaths, portraits, and scenes from daily life.

opposite:
Sunburst Quilt
Possibly Rebecca Scattergood Savery (1770–1855)
Philadelphia, 1835–45
Roller printed cottons, 113½ × 110″
Gift of Marie D. and Charles A. T. O'Neill

3. Whole-Cloth Quilt Tops are made of a single piece of fabric, often stitched in elaborate patterns and shapes.

Both pieced and appliquéd quilts are often called patchwork quilts.

QUILTING TRADITIONS

Quiltmaking was an activity that American girls began to engage in at a very early age. In her book *A New England Girlhood* (1889), Lucy Larcom wrote of her childhood in the early nineteenth century, when learning to sew began with learning to read: "We learned to sew patchwork at school, while we were learning the alphabet; and almost every girl, large or small, had a bed-quilt of her own begun, with an eye to future house furnishing. I was not over fond of sewing, but I thought it best to begin mine early."

QUILT PATTERNS

Over the years, the patterns used in quiltmaking have been given names like Sunburst, Log Cabin, Tree of Life, Ocean Waves, and One Patch. Inspired by folklore, religion, and nature, these pattern names were passed down from one generation to the next, traveling with settlers as they moved west to California. Many of the favorite patterns are still being copied by today's quilters.

THE QUILTING BEE

After a quilt top was finished, there remained the tedious task of stitching together the three layers—the top, the filler, and the back. Often this was the occasion for a working and social gathering known as the quilting bee.

The quiltmaker would invite her girl and woman friends and neighbors for an afternoon of sewing. The completed quilt top would be placed on a wooden quilting frame with the batting and the backing. The quilters would sit around the frame, stitching the three layers together, following a pattern drawn lightly in pencil on the quilt top, and exchanging news and gossip, sharing recipes and remedies. (When a quiltmaker organized a quilting bee to finish off her thirteenth quilt, she was announcing her engagement.) In the evening the men and boys of the group would join the quilters for supper and dancing. The quilting bee was an important social event and remains a tradition in certain communities today.

LOOKING AT THE SUNBURST QUILT

Quilts are very appealing because of the marvelous variety of colors and designs and the intricate workmanship that go into their creation. In cutting and assembling the dozens of small pieces of fabric the quiltmaker makes many artistic decisions. To combine colors and patterns to achieve a pleasing effect takes a lot of planning.

The Sunburst Quilt shown on page 14 is a masterpiece. The diamond-shaped patches, which are 4½ inches long, were cut from at least thirty different printed fabrics dating from the period 1835–40. A pattern of colors radiates in concentric rings from the eight-pointed star in the center of the quilt, seeming to pulsate like sunbeams moving outward from the sun.

Can you count diamond patches in the Sunburst Quilt? (Hint: there are over 2,880 patches, so take your time!) Imagine how long it took to sew all these diamond patches together! Remember, each patch is only 4½ inches long and was sewed to the next one by hand. Each patch had to be placed perfectly, since one small mistake would throw the whole pattern off. There are six to eight stitches to the inch in this quilt; if you make your own quilt, try for this number of stitches to each inch you sew.

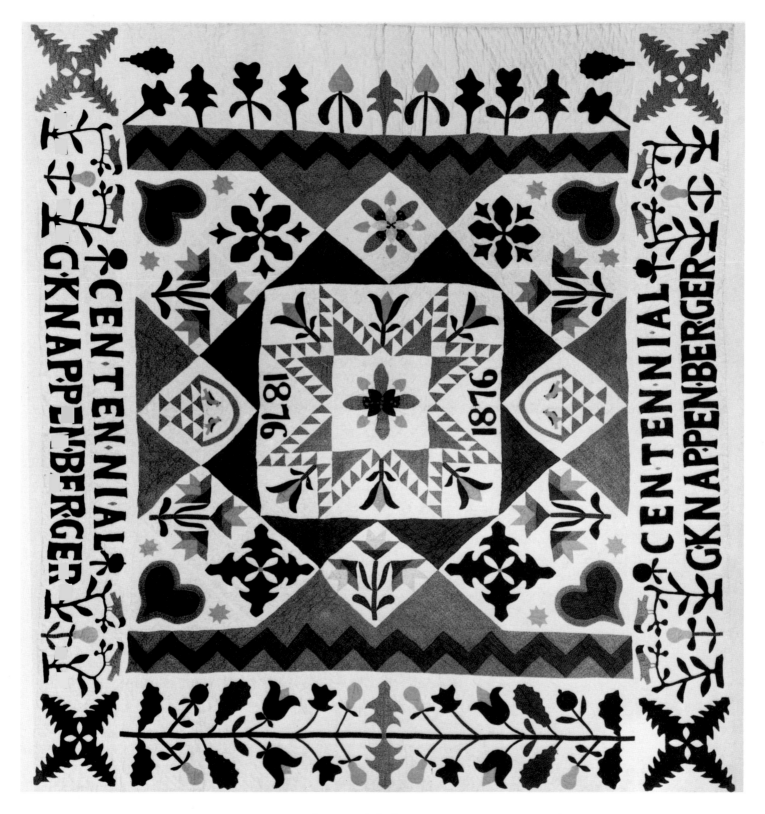

Centennial Quilt
G. Knappenberger
Probably Pennsylvania,
1876
Cotton, 71½ × 83½″
Gift of Rhea Goodman

17

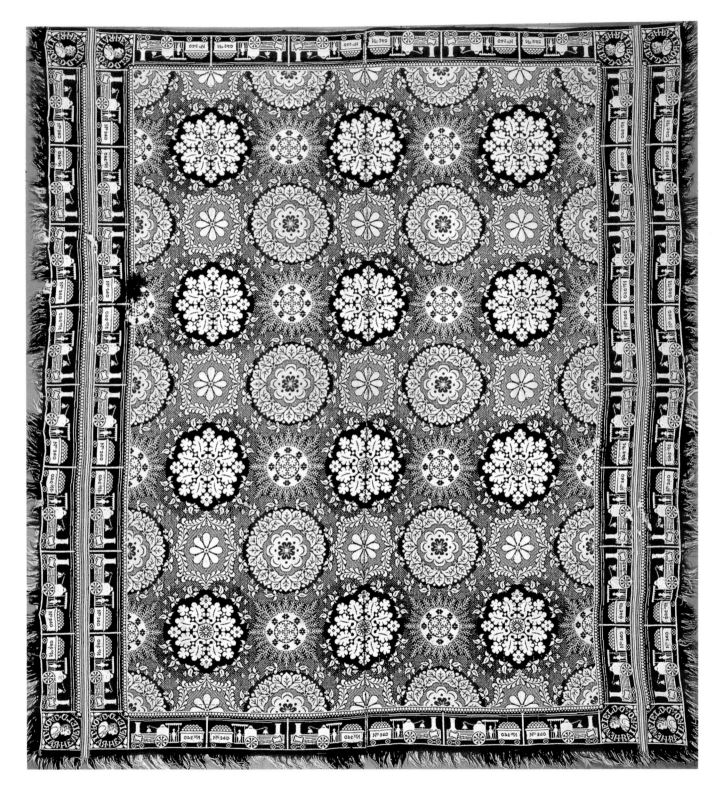

Hemfield Railroad Coverlet
Artist unknown
West Virginia or
Pennsylvania, 1850–57
Wool and cotton,
90¼ × 81″
Gift of Stephen L. Snow

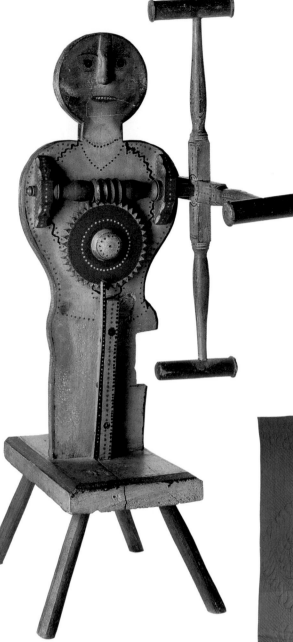

below:
Glazed Linsey-Woolsey Quilt
Artist unknown
New England, 1815–25
Glazed linsey-woolsey,
100 × 99″
Gift of Cyril I. Nelson in
honor of Robert Bishop,
Director of the Museum of
American Folk Art

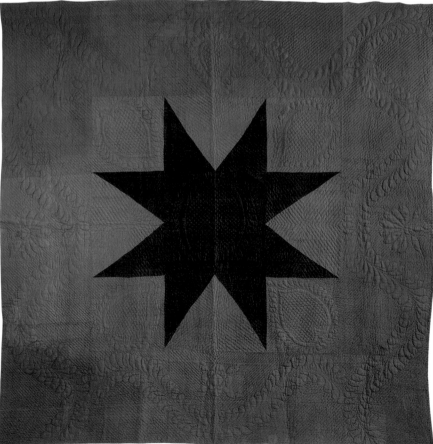

above:
Yarn Reel
Artist unknown
Possibly Connecticut,
c. 1850
Carved, turned, and
polychromed wood,
39¼ × 16 × 26⅛″
Eva and Morris Feld Folk
Art Acquisition Fund

QUILTS AS HISTORY

In the days when quilts like the Sunburst Quilt were being made, the tasks of caring for their homes and family filled up so many hours that most women had little leisure in which to express their creativity. Many of them channeled their inventive talent and imagination into quiltmaking. The women who created the most striking quilts that have come down to us might have been brilliant artists in other mediums had they lived today.

Hundreds of hours were spent composing quilts from bits of fabric accumulated by the makers and kept in scrap bags. One piece might be from a favorite dress, another from a child's bonnet—reminders of the times when these were worn. A twentieth-century writer on quilts quotes her great-grandmother as saying, "My whole life is in that quilt. It scares me sometimes when I look at it. All my joys and all my sorrows are stitched into those little pieces."

☞ You can try your hand at quiltmaking. On page 71 in the section Folk Art Projects (pp. 69–93) you will find a pattern and directions for making a doll quilt.

WHAT IS A COVERLET?

A coverlet is a woven bed cover worked in an allover pattern and made of wool and cotton.

HOW COVERLETS WERE MADE

Since it took nearly a month to weave a coverlet, they were considered a luxury. Some families had looms at home, but most coverlets were made by professional weavers on larger looms, with several weavers working together. A housewife might bring her own spun wool to the weaver and select patterns from a weaver's pattern book. First the loom would be prepared, following a prescribed pattern; then the weaving began. A wooden device called a shuttle was used to pull the wool yarn over and under the prepared threads.

LOOKING AT THE HEMFIELD RAILROAD COVERLET

The Hemfield Railroad coverlet was made by a professional weaver using a loom equipped with a Jacquard attachment, a mechanism that came into use in the 1820s (see page 18). The body of the coverlet is decorated with what is known as the "snowflake medallion" pattern. Someone with a sense of humor must have chosen this pattern for a coverlet. Imagine climbing into bed on a night so cold you could see your breath indoors, to find snowflakes all over your warm coverlet!

Woven into the border of the Hemfield Railroad coverlet is a train pattern consisting of a locomotive and a tender, or coal car. The details in the depiction of the locomotive are so precise that it can be identified as a Norris Locomotive of the 1840s. The repetition of the locomotive and tender throughout the border gives the visual effect of a complete train traveling around the coverlet.

THE HEMFIELD RAILROAD COVERLET AS HISTORY

This coverlet is thought to commemorate the opening of the Hemfield Railroad, which began operating in 1857 with a 16-mile stretch, from the West Virginia state line to Washington, Pennsylvania. On the four corners of the coverlet, a man's profile appears, surrounded by the words "Hemfield Railroad." The profile is thought to be that of Thomas M. T. McKennan, the railroad's first president. The Hemfield Railroad was never completed and in 1871 was sold to the Baltimore and Ohio Railroad and reorganized. The coverlet has long outlived the Hemfield Railroad and actually has secured its place in history. Several weavers are known to have made coverlets with this pattern, but the identity of the maker of this particular coverlet remains a mystery.

〰 Take a look at the coverlet. (A magnifying glass will help.) Notice the many

small details that were stitched into the pattern, like the "No. 240" on the side of the tender. What event in your life would you like to have commemorated in a coverlet? What design would you choose for the border? Would you like to have your profile woven into the corners?

MAKING WOOLEN YARN

Spinning wool into yarn was one of the skills that every young girl learned. After the shearing of the sheep in the spring, the wool was "carded" with special brushes to straighten the fibers. Then the wool was dyed various colors with natural dyes made from plants. Finally the wool was spun into yarn on a spinning wheel. After the yarn was spun, it was carefully wound into skeins, or hanks, small manageable units. Hours and hours were spent preparing all the yarn needed to knit wearables such as socks and sweaters and to weave blankets and coverlets.

The spinning was done at home. It was not unusual for a woman to take a spinning wheel with her when visiting a friend or neighbor. In a large household, three, four, or five spinning wheels might be found.

WHAT IS A YARN REEL?

A yarn reel is a device used to wind spun yarn into skeins, or hanks. This prevents the yarn from getting tangled or knotted. A feature on the reel, with turned spindles and gears, registers the number of revolutions of the yarn reel—a way of measuring the yarn and creating skeins of equal length. The yarn reel is simple: a base supports a perpendicular board that holds a paddle; the paddle moves round and round to hold the yarn. Handcrafted of wood, yarn reels, like spinning wheels, were common in homes until factory-made yarn made them obsolete. Now these essentials of early American life are part of social history.

LOOKING AT THE YARN REEL AS FOLK ART

The yarn reel shown on page 19 is an imaginative creation. The maker fashioned it from a single plank of wood and carved it in the form of a human shape, stylizing it into a woman by adding the simplest details—a nose, eyes, a mouth, and a series of red and blue dots and lines of paint to suggest a dress, with a string of beads at the neckline. As is characteristic of much folk art, the artist simplified the subject, choosing a few details to give a sense of it, not attempting to portray its actual reality.

WHAT IS A LINSEY-WOOLSEY QUILT?

A linsey-woolsey quilt is a whole-cloth bed cover; it takes its name from the fabric it is made of, which was handwoven of hand-dyed linen and wool.

Linsey-woolsey quilts were made between 1730 and 1830, in the days when families grew flax, which was made into linen, and raised sheep for wool. As ready-made fabrics became available in stores, by the beginning of the nineteenth century, home weaving declined and linsey-woolsey quilts were no longer popular.

This linsey-woolsey quilt (see page 19) is unusual in that it was made with a second fabric stitched into the center in the form of an eight-point star. To give the coarsely woven fabric a glossy sheen, many linsey-woolseys were, like this one, glazed. This glazed effect was achieved by two different methods. Some preferred to use a mixture of egg white and water, which was applied to the fabric and then polished with resin. A soft stone could be rubbed on the fabric until the desired gloss was achieved.

⚬ᴖⴱ Take a few minutes to examine the beautiful patterns formed by the intricate stitches that hold the three layers of this whole-cloth quilt together. Notice the four hearts within the points of the star. They suggest that this may have been a bridal quilt.

Off to School

Multiplication is vexation,
Division is as bad;
The Rule of three doth puzzle me,
And Practice drives me mad.

—16th-Century Rhyme

SOME OF THE MOST CELEBRATED American folk artists were schoolchildren. The work of these young people is a testament to their natural artistic ability and to the effort and concentration that went into their schoolwork.

When families settled in a new community, a church and a schoolhouse were the first structures built. The early schools were simple one-room buildings, heated by a fireplace or, later, by a wood stove. While the law required that each town provide a school, attendance was not compulsory. When many hands were needed to help on the farm, children's early education often came from working alongside their parents. But as the country prospered and grew, more and more schools were established and most children soon spent their days at school rather than at home.

Some families sent their children to dame schools, small neighborhood schools that both boys and girls attended between the ages of four and nine. Older girls might be sent to boarding schools, finishing schools, academies, or seminaries. The curriculum at these day schools included not only reading, writing, and arithmetic, but music, dancing, drawing, and plain and fancy needlework. Works created by students in these schools—samplers, calligraphy drawings, and theorem paintings—are among the significant body of objects of American folk art that is treasured and exhibited today.

WHAT IS A SAMPLER?

A sampler is a decorative piece of needlework intended to give practice in sewing various stitches and to record letters, numbers, and designs—and to serve as a "sample" statement of the ability of the maker.

It is thought that nearly every girl who attended school created a sampler to provide practice in working numerals and the alphabet. For the first alphabet sampler, the simple cross-stitch was taught as well as other stitches for plain sewing. In 1841, Catherine E. Beecher, in her book *A Treatise on Domestic Economy,* wrote: "Every young girl should be taught to do the following kinds of stitches, with propriety. Overstitch, hemming, running, felling, stitching, back-stitch and run, button-stitch, chain-stitch, whipping, darning, gathering, and cross-stitch."

These were the stitches a woman would need to use throughout her life for making and mending the clothes and linens for her family. It was her responsibility to make the dresses, jackets, and shirts, the towels, sheets, pillowcases, blankets, coverlets, and quilts, and accessories like handkerchiefs, collars and cuffs, bonnets and pinafores, for her family. Needle and thread were also used to "mark" linens with initials and numbers for safekeeping.

opposite:
Sampler
Lucy Low (1764–1842)
Danvers, Massachusetts, 1776
Silk on linen, 14½ × 11⅜"
Promised anonymous gift

Young women who attended seminaries and academies also created more decorative pictorial samplers, which were framed and prominently displayed in the home. Today many of these samplers and needlework pictures can be traced through their design elements to specific schools. The teachers at many schools carefully guided the students, providing the pattern, stitches, and techniques.

MAKING A SAMPLER

A sampler was stitched on a rectangular or square piece of linen, hemp, or silk. A design copied from a pattern provided by teacher or mother was drawn on the cloth with pen or pencil. Using a variety of colored silk or linen embroidery threads and a variety of stitches, the young needleworker painstakingly transformed the pattern into an embroidered picture.

A child's first sampler usually consisted of the capital letters of the alphabet, followed by the lowercase letters and the numbers 1 through 10. Most makers also stitched in their name and the date they finished the sampler. Twelve-year-old Caroline Richards of Canandaigua, New York, wrote in her diary of 1854: "I am making a sampler . . . and have all the capital letters worked and now will make the small ones. It is done in cross stitch on canvas with different color silks. I am going to work my name, too." Later samplers included poems, verses, and sometimes complaints from the seamstress about the difficulty of the work.

LOOKING AT LUCY LOW'S SAMPLER

A girl's best sampler was valued by her family as proof of her ability as a needlewoman, which might impress a suitor. And indeed a girl's suitability for marriage is one of the themes found in the designs and verses of samplers. In Lucy Low's sampler, shown on page 22, a colonial couple is surrounded by pairings of birds, animals, and trees. Can you find all nine of these pairings? Like the paired designs, frequently used as a symbol of marriage, the verse on the sampler also refers to marriage:

"O May I Always Ready Stand
With My Lamp Burning In My Hand
May I In Sight Of Heaven Reioice
& Ioy To Hear The Bridegrooms Voice"

You can discover the makers of many samplers by finding their name stitched in the pattern. Can you find Lucy Low's name in her sampler? Now examine carefully—using a magnifying glass if available—the letters of Lucy's alphabets. Do you see that they are missing the letter J? In fact, the letter J is missing in most samplers made in the 1700s. This follows the practice in early printing: up until the seventeenth century the letters I and J had not yet been differentiated. You can see that the letter I is used instead of the letter J in the verse in the words that we would spell "Rejoice" and "Joy."

You can try out your needlework skills by creating a sampler of your own, using the patterns and directions provided on page 77 in the section Folk Art Projects (pp. 69–93). After working on your sampler you will appreciate the time and skill that Lucy Low, aged twelve, stitching away in the colony of Massachusetts during the first year of the War of Independence, put into her work.

WHAT IS CALLIGRAPHY?

Calligraphy (the term means "beautiful writing") is an art with a very long history. It has been actively practiced for centuries. And for all these years calligraphers have delighted in enhancing their handwritten works with drawings created by using the very same strokes and flourishes as are used to form letters.

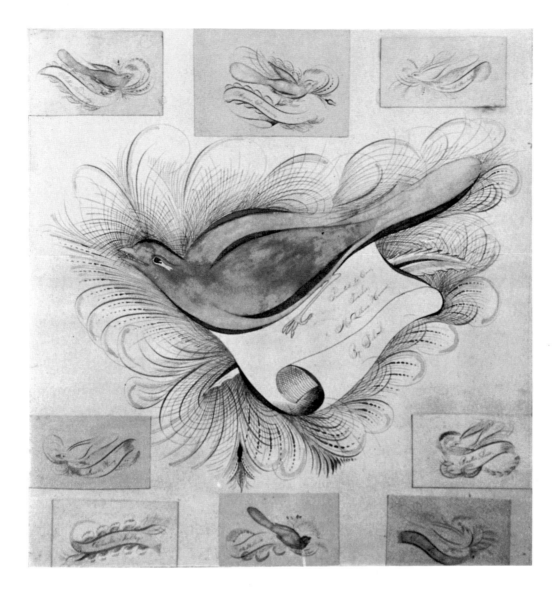

Penmanship was taught in American schools from the earliest days. It was thought to be important as a tool for success and as the hallmark of a cultivated person. Everyone wrote with a quill pen until the mid-nineteenth century. Each child had to take his or her own goosefeather quill pen to school, and it was the teacher's duty to keep it sharp. The pupils used homemade ink and practiced their penmanship by writing poems and other selections in copybooks. Steel-tip pens came into use by the middle of the nineteenth century, and professional penmanship masters created elaborate calligraphy drawings, for pleasure and for profit.

HOW WAS CALLIGRAPHY LEARNED?

"Let the pen glide like a gently rolling stream,
Restless but yet unwearied and serene;
Forming and blending forms with graceful ease,
Thus Letter, Word and Line are born to please"

—Quoted in "Calligraphy: 'Why Not Learn to Write' "
(Museum of American Folk Art, 1975)

Spencerian Birds
Calligraphic drawing
Miss Lillian Hamm and her students
Region unknown, c. 1850
Pen and ink and watercolor on wove paper, 18¾ × 17¾"
Promised gift of Cyril I. Nelson

25

The material that young Americans practiced on was copied from handwriting manuals and drawing copybooks. One of the most popular manuals was the work of Platt Rogers Spencer (1800–1864); his style of writing is still known as Spencerian penmanship, and compositions in that style, like the one shown here, are called Spencerian drawings.

When looking at calligraphy drawings, remember that the basis of this art form is the study of lines. Lines can be straight or curved, thick or thin. Straight lines convey strength and solidity. Curved lines give a feeling of motion, grace, delicacy. The spaces between lines constitute another element of these drawings. Using repeated cursive strokes, the pen can create birds in flight, perched eagles, roaring lions, galloping or prancing horses, leaping deer; it can express energy, movement, and elegance not easily conveyed by any other instrument.

ᘓᴗᴏ Calligraphy drawings consist of both writing and drawing, as exemplified in this drawing by Miss Lillian Hamm's students (see page 25). Using the Spencerian system, the students drew birds and wrote their names on small cards, then pasted them on a larger piece of paper to form a single composition. Notice that the birds were outlined first in ink with a pen and then watercolored with a brush. The inscription on the bird in the center reads: "Presented to Our Teacher Miss Lillian Hamm. By School." Try to read the names of all the students.

WHAT IS A THEOREM PAINTING?

"Theorem" is another word for stencil. Created with the aid of a theorem, this kind of painting is a still-life composition made either with pastels on paper or with watercolor on paper or velvet.

HOW WAS A THEOREM PAINTING EXECUTED?

Theorem paintings were another popular schoolgirl art; their popularity, amounting to a fad, peaked from 1820 to 1840. In preparing to make a theorem painting, the first step was to decide on a still-life design. Often the subject of fruits in a bowl was chosen from designs suggested by the teacher. Then a theorem was made in the shape of each object in the still life. The theorems were cut from heavy paper that had been shellacked and oiled to form a stiff, strong surface. The stenciled designs were then carefully applied, one at a time, onto paper or fabric with special stiff brushes. Using up-and-down motions—dabbing rather than stroking—the paint was forced through the cut-out theorems and onto the background paper or fabric. To finish the theorem painting, details were sketched in freehand with calligraphy pens or small brushes.

LOOKING AT THE FRUIT, BIRD, AND BUTTERFLY THEOREM PAINTING

Using stencils made it possible for anyone to create a reasonable likeness of the objects in a still life. The choices made by the artist in the composition, shading, and combination of shapes and details are what folk art experts look for in judging the quality of theorem paintings.

ᘓᴗᴏ This theorem painting is carefully and skillfully executed. Notice the shading of the grapes and plums. They look round and ripe. The details of the butterfly's wings, the bluebird's feathers, the veins in the leaves, and the stem marks on the fruit, delicately and beautifully drawn freehand, help to give the theorem an illusion of depth and realism. This simple, clear work by a talented folk artist captures the essence of common things.

☞ You can try your hand at theorem painting, using the directions on page 74 in the section Folk Art Projects (pp. 69–93). This is a very satisfying activity, because with the help of stencils it is not hard to create an artistic composition. Then with pen, pencil, or brush, you can add the details that will give these simple forms the look of reality.

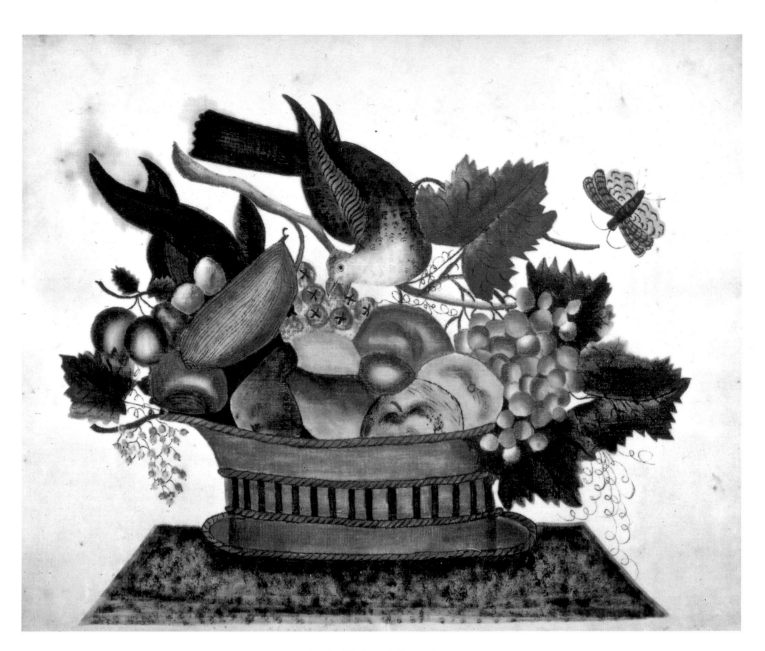

**Fruit, Bird, and Butterfly
Theorem Painting**
Artist unknown
Possibly New England,
1825–40
Watercolor on velvet,
15⅜ × 18¾"
Gift of Mrs. William P.
Schweitzer

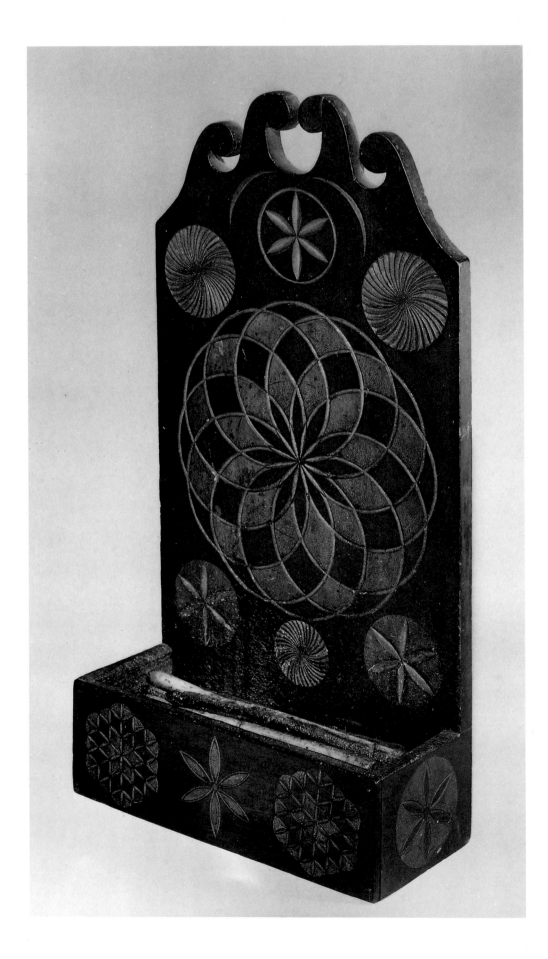

In the Kitchen

...the great, old-fashioned kitchen, which, on ordinary occasions, is the family dining and sitting room.... The floor ... of snowy boards sanded with whitest sand; ... the ancient fireplace stretching quite across one end,—a vast cavern, in each corner of which a cozy seat might be found, distant enough to enjoy the crackle of the great jolly wood-fire; across the room ran a dresser, on which was displayed ... pewter dishes and plates, which always shone with the same mysterious brightness; and by the side of the fire, a commodious wooden "settee," or settle, offered repose to people too little accustomed to luxury to ask for a cushion. Oh, that kitchen of the olden times....

—Harriet Beecher Stowe, *The Minister's Wooing*, 1859

IN THE HOME, THE KITCHEN was the center of family life. A large fireplace dominated the room, providing light, warmth, and heat for preparing food. This was where all the meals were cooked. Meat was roasted on the spit that revolved over the glowing coals; bread was baked in the brick oven built into the chimney.

And most of the other household chores were performed in the kitchen. Soap was made, clothes were washed, candles were dipped, medicinal syrups were brewed, wool yarn was dyed. In front of the fireplace women made garments, stitched quilts, taught their children the alphabet, and entertained guests.

Beside the hearth, on the kitchen walls, and in the cabinets and drawers were the various objects required for the numerous chores and procedures that feeding, clothing, and caring for a family entailed. Metal cookie cutters, pottery crocks and pitchers, tin candle molds, pewter candlesticks, as well as coffeepots, knives, forks, spoons, table linens, spinning wheels, baskets of all sorts and sizes, iron kettles, and wooden butter molds—almost all were handmade, and many were enhanced with painted or carved decoration. Some were personalized, to be presented as gifts. Although strictly utilitarian in purpose, these objects, created with skill and artistry, have come to be known as folk art.

CANDLE MAKING

Before the invention of gas and electric lighting, homes were lit with candles and oil-burning lamps. Candle making was another of the chores tended to by country women. Every little girl knew the verse "Provide thy tallow ere frost cometh in, /And make thine own candle ere winter begin."

Candles were made from tallow, the rendered fat of cattle and sheep, so candle making usually followed the yearly slaughter of animals on the farm. The fat was melted in large kettles of water; the tallow rose to the top and then was skimmed off. Candles were also made from the waxy berries of the bayberry shrub, and from beeswax gathered from the beehives in herb gardens outside kitchen doors.

Two methods were used for making candles. Some preferred to take a string wick and dip it over and over again into the hot tallow or bayberry wax until the candle was of the proper thickness. Others preferred to pour the hot tallow or bayberry wax into

opposite:
Hanging Candle Box
Artist unknown
Connecticut River Valley,
1790–1810
Carved and painted wood,
24⅝ × 12¾ × 5⅜"
Museum of American Folk
Art purchase

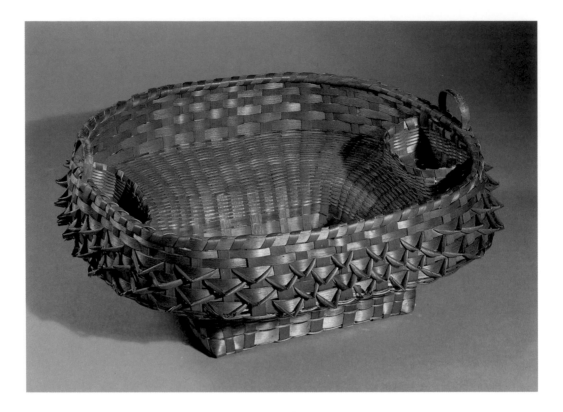

Sewing Basket
Artist unknown
Northeastern United
States, c. 1920
Ash splint, red dye,
wood, diameter 13½″
Promised gift of Judith
A. Jedlicka

a tin candle mold containing a wick. It usually took two or three days to make enough candles to last a year. The bulk of the candles were stored in a cool spot; a smaller collection was placed in a candle box for handy access.

LOOKING AT THE HANGING CANDLE BOX

The candle box is an example of a utilitarian object beautifully decorated. The careful and exuberant decoration indicates it may have been intended as a gift.

Look closely at the designs incised on the box: the raised pinwheel, the star, and the flower. These are designs often used by carpenters on tables, chests, and chairs made throughout western Connecticut and Massachusetts during the eighteenth and nineteenth centuries.

Each time someone's hand reached into the box for a candle, fingernails removed a bit of the black paint. Do you see the resulting wear marks on the left side of the box, just above the top of the candles? When this candle box came to the Museum it still contained the nineteenth-century candles you see here.

The pinwheel, star, and flower were made using a compass, a common tool of carpenters. Try your hand at creating designs with your own compass on a sheet of paper by marking the center and then drawing overlapping circles at even intervals and coloring in the alternating segments that are formed.

BASKET MAKING

Native Americans were making baskets long before the first settlers arrived. Colonial families learned from the Indians how to weave large, sturdy field baskets using reeds and wood splints. While most farm families wove baskets only for their own use, a few families did make hundreds of baskets during the winter for sale and trade in the spring. Baskets began to be made by machine about 1850.

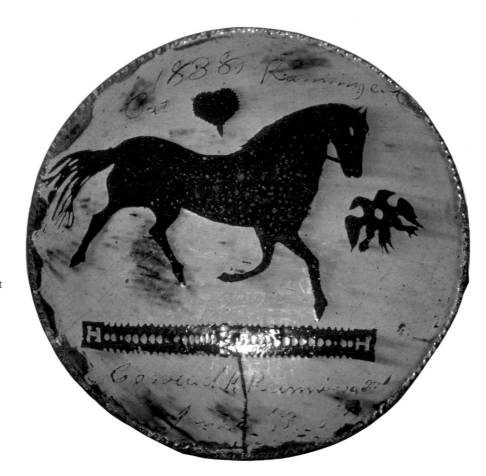

Slipware Plate
Signed Conrad K.
Ranninger
Probably Pennsylvania
Dated June 23, 1838
Redware
Promised anonymous gift

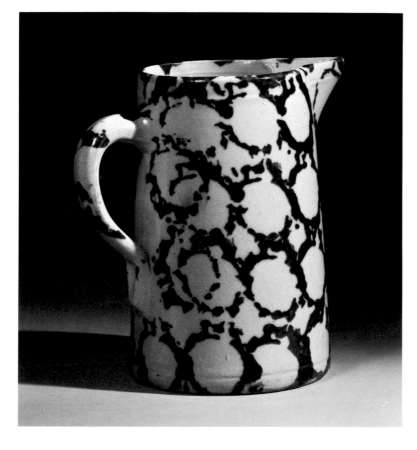

Stoneware Pitcher
Artist unknown
Probably New Jersey or
Ohio, 1875–1910
Sponge-decorated
stoneware, $8\frac{7}{8} \times 8\frac{1}{4} \times 5\frac{7}{8}$"
Museum of American Folk
Art purchase

31

BASKETS FOR EVERY USE

Baskets were as common in the nineteenth century as shopping bags of paper and plastic are today. Country men and women used baskets many times during the course of the day. Different baskets were made for different purposes. There were egg baskets for carrying freshly laid eggs from the chicken coop to the kitchen and heavy, wooden-handled baskets for carrying apples from the orchard. There were also laundry baskets, wool-rinsing baskets, table baskets for fruit, storage hampers, market baskets, flower baskets, and berry baskets. Probably the most used of all was the sewing basket.

LOOKING AT THE SEWING BASKET

Sewing baskets were used for storing a myriad of sewing implements—pins, needles, scissors, thimble, embroidery yarns, thread, pin cushion, and darning bulb. In constant use, the sewing basket was often carried from place to place—from room to room and from house to house as women took their mending and needlepoint with them when they went visiting.

This sewing basket (see page 30) is in very good condition. The smaller compartments on either side were used for pins and needles. Working with fine- and medium-width splints, the maker used a basket mold to help form the basket's unusual shape. If you look closely at the inside, you will discover that a red dye (made from berries) was applied to the first wide splint near the bottom of this lovely basket.

WHAT IS POTTERY?

Among the first objects crafted in the American colonies were pottery jugs, crocks, jars, plates, bottles, pitchers, and other containers; they were made from clay hardened by firing in special ovens known as kilns. As early as 1635 there were three potters working in New England. They fired their pottery in small "groundhog kilns," so named because they were barrel-shaped, like that animal. By the end of the seventeenth century, nearly every coastal community had its local potter.

POTTERS AND POTTERIES

Potters were important members of the community; their products, which, in addition to dishes, plates, cups, pitchers, and mugs, included such other necessities as inkwells, lamps, and washbasins, were essential for everyday life. A young person would begin working as an apprentice to a potter around the age of sixteen, first preparing the clay and gradually learning the other techniques of the craft. Pottery was often decorated with flowers, birds, and animals and other designs. A pottery usually identified its wares by using a stamp (pressed on the wet clay before firing) giving its name and location. With jugs and pitchers, sometimes a numeral indicated their capacity.

There are two basic types of pottery represented in the collection of the Museum of American Folk Art: redware and stoneware.

Redware was the earliest pottery made in America. This ware was made from a number of common clays found throughout the country. The clays varied in color from tan to red, but when fired they all turned a shade of red. Redware was coated with a clear lead glaze that formed a glasslike surface which kept liquids from seeping out. Because it was rather brittle and fragile, by the end of the eighteenth century redware began to be replaced by the more durable pottery known as stoneware.

Stoneware was made from a fine clay that was blue to white in color and turned tan to light gray when heated. Firing at high temperatures produced a strong, compact pottery. Stoneware clay was found in Ohio and throughout the Atlantic coastal states but not in New England, where most redware was made. Stoneware could be

glazed during firing by the throwing of common salt into the kiln when it had reached a very high temperature; the sodium element in the salt combined with the silica in the clay to form a shiny, impervious finish.

MAKING POTTERY

The clay used in making redware and stoneware pottery was found under the topsoil near streams and ponds and along the seashore. After the clay was dug, it was ground in a mill, cleaned, mixed with water, and formed into large blocks. Potters sliced off a section of the clay and kneaded it to remove all air pockets. A vessel such as a bowl was shaped by draping a slab of prepared clay over a mold or by being "thrown" on a potter's wheel. While the clay was still damp, potters, using a variety of tools, decorated the surface of the soft clay and also added handles or spouts as needed. The vessels were then stacked in the kiln and baked. Redware kilns baked for at least thirty to forty hours; they were heated by burning wood to reach 1700° Fahrenheit. Stoneware was fired in kilns (often room-sized) strong enough to withstand 2300° Fahrenheit, much hotter than redware kilns. Controlling the temperature of the kiln was a difficult task, and a whole kiln-full of pots could be ruined if the temperature became too high or was not high enough.

WHAT IS SLIPWARE?

The slipware technique is a way of creating colored decoration on pottery. Using this method, the potter applied slip, a thin mixture of clay and water, much as paint was used to decorate wood. The colored slip was applied with a brush or by dribbling or trailing it (from a small, cuplike device called a slip cup) in a variety of shapes and patterns. To outline a design, a technique known as sgraffito was used. With a pointed tool, the potter scratched away the slip, partially exposing the red clay underneath, and drew elaborate designs—flowers, birds, horses, people—and even inscribed verses, messages, and names and dates.

LOOKING AT THE SLIPWARE PLATE

The decorative slip and sgraffito techniques were widely used by the master potters of Pennsylvania. The elaborate designs and inscriptions appeared primarily on presentation plates and pie plates, which were often given as gifts and used decoratively in the kitchen. The fanciful plate seen on page 31, signed "Conrad K. Ranninger" and dated June 23, 1838, is an example of these rare and treasured works of folk art. The heart and double-headed eagle, typical motifs from Germany, appear in folk art of this region.

There is a mystery surrounding the potter of this plate. All plates known to have been made by Conrad K. Ranninger are dated June 23, 1838. Folk art historians wonder if this superb potter simply made enough plates to fill a single kiln and then gave up pottery making altogether. Further research may reveal more about the life of Conrad K. Ranninger.

LOOKING AT THE STONEWARE PITCHER

The sponge-decorated stoneware pitcher with its blue markings (see page 31) is a fine example of the classic simplicity of many of the household objects created by local potters. Sponge-decorated stoneware was popular during the latter half of the nineteenth century; the sponging technique had been used on boxes, blanket chests, and furniture earlier in the century. It involved dipping a sponge into a colored slip and dabbing it randomly or in a pattern over the outside of the vessel before firing.

☞ You can sponge-decorate some of your own favorite objects using a regular household sponge and following the suggestions on page 89 in the section Folk Art Projects (pp. 69–93).

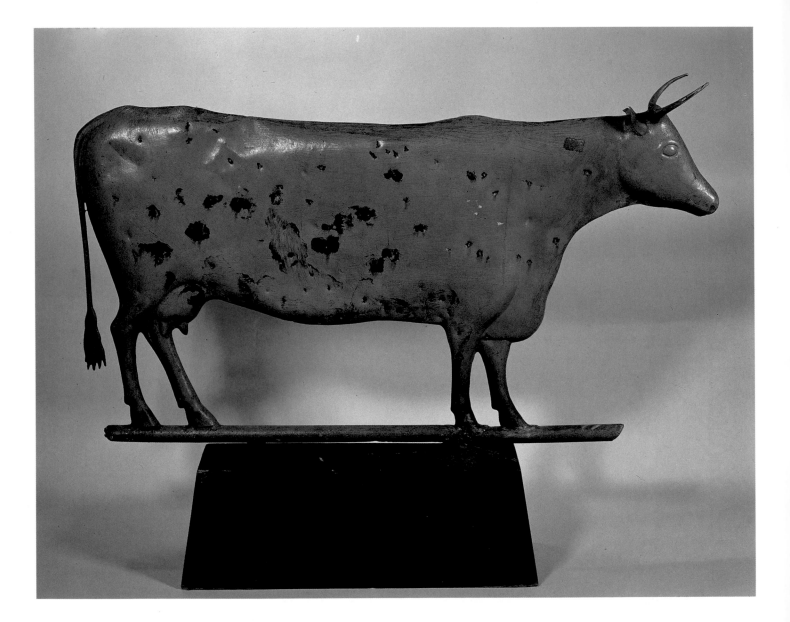

On the Farm

The glory of the farmer is that, in the division of labors, it is his part to create.... He stands close to Nature; he obtains from the earth the bread and the meat. The food which was not, he causes to be.

—Ralph Waldo Emerson, *Society and Solitude: Farming,* 1870

UNTIL AFTER THE CIVIL WAR most Americans were farmers. The activities of a weaver, a fisherman, a soldier, a doctor, a teacher, a shoemaker, a carpenter were carried out in addition to the primary task of working the land. The family was clothed and nourished by the fruit of their own labor. From head to toe they were clad in products of their own creation. The leather for their shoes came from the hides of their cattle, the linen and wool cloth from the flax they grew and the sheep they raised. They wove the straw hats they wore in the summer. Fur caps for winter were made from the skins of foxes and chipmunks native to the fields and forests. Feathers plucked from the farm's own geese filled the featherbeds and pillows. The sheets, blankets, quilts, towels, and tablecloths were all homemade. The harnesses and the reins for the horses were cut from hides of animals raised on the farm. The handles of whips, axes, hoes, and pitchforks were carved from the wood of trees on the land.

The farmer's wife and entire family were all members of a self-supporting working group. To be sure, neighbors often came together to help with harvesting, husking, and barn raising. The never-ending daily cycle of work on the farm was the core of daily life. These American farm families were not only hard-working; they were also inventive. If something was needed, they made it. Many of the surviving tools and artifacts created to complete specific tasks—often decorated to please the eye of the maker— are treasured as objects of American folk art.

WHAT IS A WEATHER VANE?

A weather vane is an object, usually made of wood or metal, designed to indicate the direction of the wind. In the countryside and in villages and towns weather vanes were mounted on top of the highest structures.

Nowadays, the weather forecast is always available—on television, on the radio, or in the newspaper. But before the development of the science of meteorology, people relied on weather vanes to help them predict the weather. From experience it was known that certain prevailing winds usually brought certain changes in weather. Different parts of the country have different wind patterns. In one region an east wind brought the rain: a quick glance at a weather vane could alert the farmer, the sailor, and the traveler to an oncoming storm. If a storm was approaching, the farmer could hasten to harvest his fields, and the fisherman might delay casting his nets.

opposite:
Cow Weather Vane
Possibly L. W. Cushing & Sons
Waltham, Massachusetts, 1870–80
Painted copper, cast and stamped, 17 × 28 × 6"
Gift of Mrs. Jacob M. Kaplan

HOW THE WEATHER VANE WORKS

To show which way the wind blows, the weather vane was at first devised as a flat surface mounted on a vertical axis, or rod, around which it could move freely. One of the favorite weather vane designs, the rooster, is a good illustration. It is not a symmetrical, or balanced, form. The part with the greater area—the tail—offered more resistance to the wind, and thus the wind moved the rooster so that its head pointed in the direction from which the wind was blowing. Whether it was north, south, east, or west was indicated by the directionals N S E W placed around the middle of the rod.

MAKING WEATHER VANES

The early weather vanes were fashioned of wood, tin, or hammered copper and were made by farmers, carpenters, fishermen, and blacksmiths. These flat, two- or three-dimensional vanes were often enlivened with paint or adorned with iron details. After the 1850s, the majority of weather vanes was mass-produced; for the most part, these vanes were cast in iron or molded in sheet copper, and three-dimensional forms like the cow weather vane were favored.

LOOKING AT WEATHER VANES

Weather vanes are part of the sculpture tradition in American folk art, and it is for their beauty, originality, and sculptural qualities that they are displayed in the Museum.

Weather vanes were made in many shapes. On the top of his barn, a farmer might mount a horse or other farm animal; a church steeple usually had a weather vane in the shape of a rooster, a fish, or the archangel Gabriel. In seaports, weather vanes were often in the form of fish, whales, mermaids, ships, and sea serpents. Shop owners sometimes chose weather vanes that symbolized what the shop sold and thus served as a kind of advertisement, much like a trade sign. Town halls and other public buildings favored eagle or flag weather vanes. Here are some favorite shapes: Gabriel, Sea Serpent, Eagle.

Silhouetted against the sky, weather vanes were made to be seen from a distance. Their function was to indicate the wind direction at a glance, and for clarity and effectiveness their forms are often exaggerated and their proportions out of scale. It is this boldness of form, together with the ingenuity of their designs, that captivates collectors of folk art today.

WHAT IS A DECOY?

A decoy is a carved wooden model of a bird used by hunters to attract real birds to within shooting distance. Decoys placed near the water entice waterfowl into believing that it is safe to alight.

The decoy as a hunters' device has a long history. Native Americans shaped decoys of rocks, mud, and roots to lure ducks and game birds within striking range of their bows and arrows.

There are two kinds of decoys: (1)"floating" decoys, designed to ride the surface of the water; (2) "stick-up" decoys, designed to be mounted on a stick and set up in the sand or a marsh in a feeding area.

LOOKING AT DECOYS AS ART

Since hunting wildfowl was a widespread activity, thousands of wooden ducks, geese, gulls, herons, and swans were carved and painted throughout America. The prime purpose of decoy carving was to create the impression of a live bird, not necessarily to make an exact replica. While it was not essential to paint a decoy in order to attract birds, many makers—among them farmers, fishermen, and sea captains—did so for their own pleasure.

**Saint Tammany
Weather Vane**
Artist unknown
East Branch, New York,
mid-nineteenth century
Molded and painted
copper, 10½ × 103 × 12″
Museum of American Folk
Art purchase

Sea Serpent Weather Vane
Artist unknown
New England, c. 1850
Painted wood, iron,
16½ × 23¼ × 1″
Museum of American Folk
Art purchase

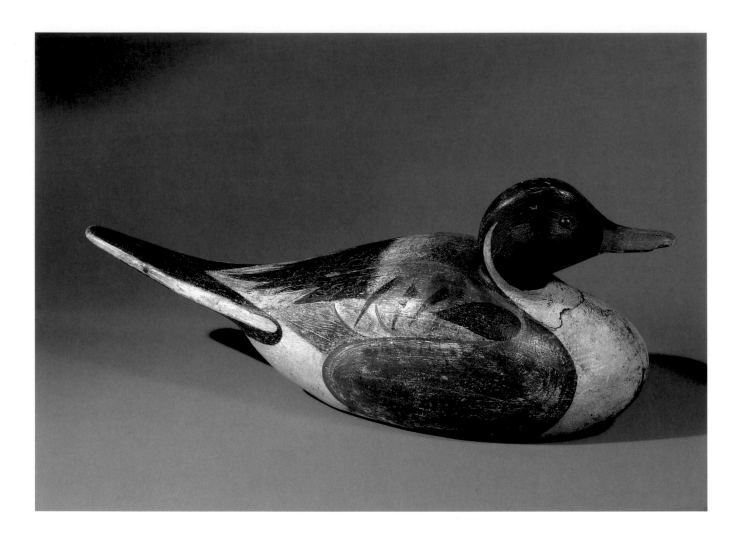

Pintail Drake Decoy
Steve Ward (1895–1976)
and Lem Ward (b. 1896)
Crisfield, Maryland,
c. 1935
Polychromed wood, glass,
8 × 18 × 6½"
Gift of Alastair B. Martin

Steve and Lem Ward, the makers of the pintail drake decoy shown here, are considered masters of their craft. These two brothers made their living primarily as barbers but were also artists who carved and painted thousands of decoys. Lem was considered the more artistic of the two, though he had never had any formal training. He painted this decoy, which was carved by Steve. Lem's painting technique conveys the essence of the duck; the plumage is rendered with graceful, simple overlapping planes of color.

Most carvers did not sign their work. If a name or initial does appear on a decoy, it usually indicates the owner rather than the carver. Such labeling helped prevent any decoys that were washed ashore during a storm from being pilfered.

Until the beginning of the twentieth century a hunter could shoot any number of birds, for sport or for food. But conservation laws now place limits on hunting, and decoys are admired as a decorative art form and seen in living rooms and art galleries.

FENCES AND GATES

On the earliest American farms a "cow tender" herded the livestock, making sure that the animals stayed on their own land. But soon nearly every farm had its fences. The network of fences kept the farm animals in and the wild animals out. A fence defined a farmer's property, providing a sense of order and pride in his domain. Fences also prevented disputes over boundaries, as the old adage "Good fences make good neighbors" suggests. It goes without saying that fences need gates.

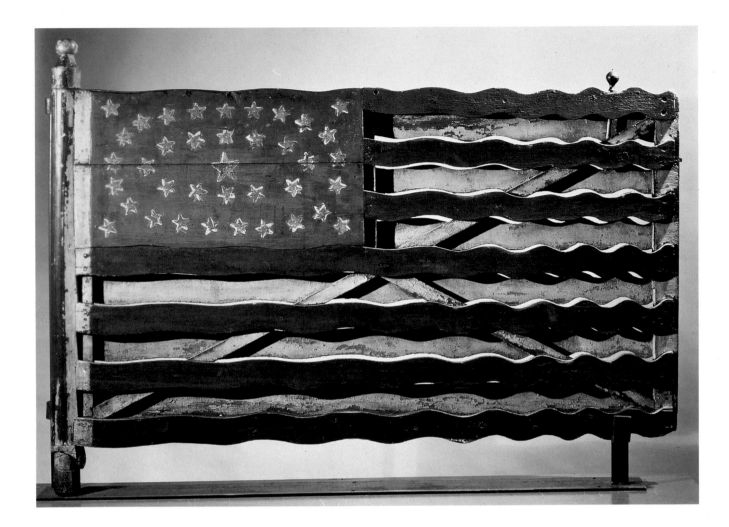

LOOKING AT THE FLAG GATE AS ART

The Flag Gate is an especially appealing example of folk art because the decoration speaks louder than the object's function. This gate did not just serve to close an opening in a fence; it was conceived by its maker as an American flag proudly waving in the wind. It was beautifully designed, carved, and painted, and gave expression creatively to a powerful message.

⟳ If you look carefully at the gate, you will notice that the maker used the device of carving wooden stripes in wavy lines to make the flag look as if it were waving in the wind. And the gate is painted on both sides, so that either coming or going the opener of the gate saw the flag.

Instead of arranging the stars in rows, as was usual on the official American flag, the artisan laid them out in an elliptical pattern more pleasing to his own eye.

DATING THE FLAG GATE

The Flag Gate is by an unknown maker, but evidence of its age is apparent to folk art historians. Counting the stars—thirty-eight—they deduce that the gate was made after Colorado (the thirty-eighth state) was admitted to the Union, in 1876. Furthermore, 1876 was the year of the Philadelphia Centennial, celebrating the first one hundred years of the American Republic. This was surely the perfect year for an American farm family to express its appreciation and pride by decorating their gate with the flag of their country.

Flag Gate
Artist unknown
Jefferson County, New York, c. 1876
Polychromed wood, iron, brass, 39½ × 57 × 3¾"
Gift of Herbert Waide Hemphill, Jr.

39

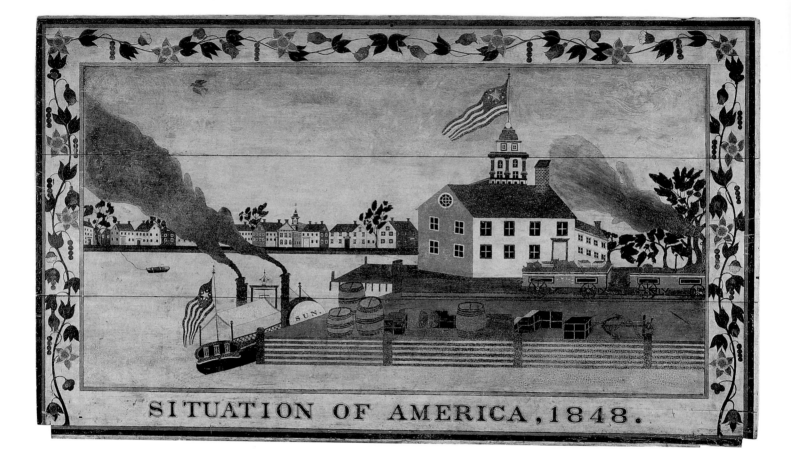

SITUATION OF AMERICA, 1848.

Into Town

There was a general exchange of news, as the different farm-wagons stood hitched around the door [of the general store], and their owners spent a leisure moment in discussing politics or theology from the top of the codfish or mackerel barrels, while their wives and daughters were shopping among the dress goods and ribbons.

—Harriet Beecher Stowe, *Oldtown Folks,* 1869

As clusters of families came together to form communities throughout the expanding country, the American town developed a characteristic pattern. In the center was a village green, and facing on it were a meetinghouse, a red schoolhouse, and one or two tall-steepled churches. On Main Street, a general store, a blacksmith shop, a tannery, a pottery, an apothecary shop, a tavern, and a doctor's office might be found among the tidy clapboard houses. By the 1830s, towns and cities were centers of trade, commerce, and other activity. No longer did the American family have to make its own fabric, coverlets, shoes, belts, jackets, brooms, and candles; they came into town to buy or barter for what they needed. Urban centers also became the focal point for town meetings, for weddings, funerals, and baptisms, and for commerce, trade, and government, and these activities drew increasing numbers of people to visit and to take up residence.

LOOKING AT *SITUATION OF AMERICA, 1848*

Situation of America, 1848 documents the city of New York at a prosperous time in its history, the late 1840s. This cityscape, painted on the wooden panel that surmounted a fireplace, is a many-sided celebration. It celebrates America: note the two flags waving in the breeze. It celebrates the steam engine: note the smoke billowing from both the train and the boat across the blue sky. It celebrates trade and commerce: note the docks filled with wares. The eagle in the sky, the stately courthouse, the ordered, gaily colored houses and buildings, the bright, cloudless sky, all convey the artist's optimism about New York in 1848.

It is thought that this is a view of Manhattan seen from Brooklyn across the East River. If you are familiar with New York today, you will recognize the dome of City Hall and the spire of Trinity Church.

WHAT IS A TRADE SIGN?

To attract customers to their establishments, artisans and shopkeepers hung signs outside to identify their wares and their services. These trade signs are one of the earliest forms of advertising.

The making of trade signs came to be a specialty. Sign painters and carvers earned their living by creating the many signs that were needed by shops, taverns, tradesmen, and professionals. Their aim was to catch the attention of the passerby and provide an immediate picture of the product or service offered.

opposite:
Situation of America, 1848
Artist unknown
New York, 1848
Oil on wood overmantel,
34 × 57"
Promised anonymous gift

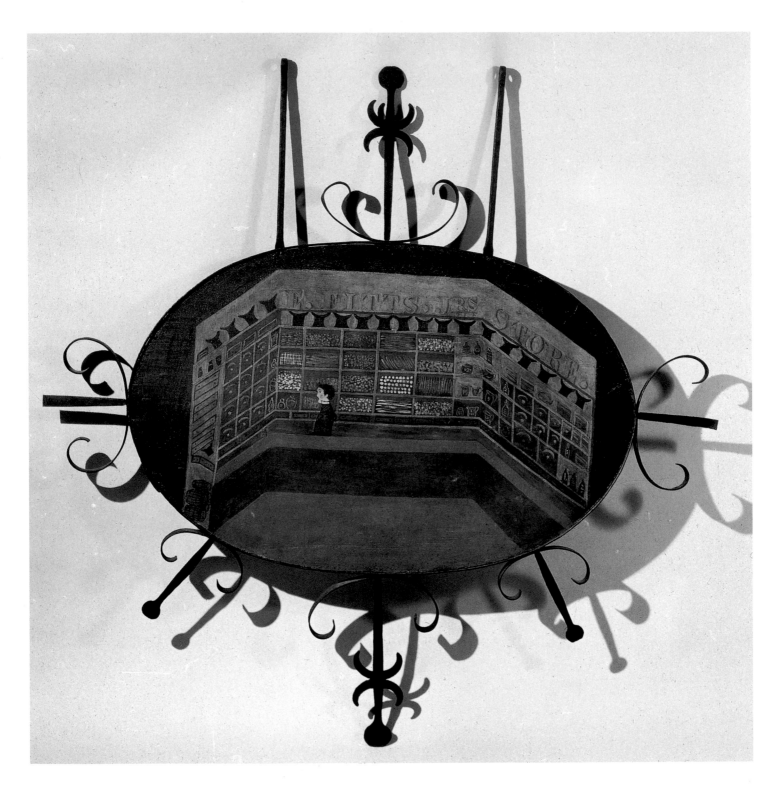

**E. Fitts, Jrs. Store and
Coffeehouse Trade Sign**
Artist unknown
Vicinity of Shelburne,
Massachusetts, dated 1832
Polychromed wood,
wrought iron, 22⅜ × 34½″
Gift of Margery and Harry
Kahn

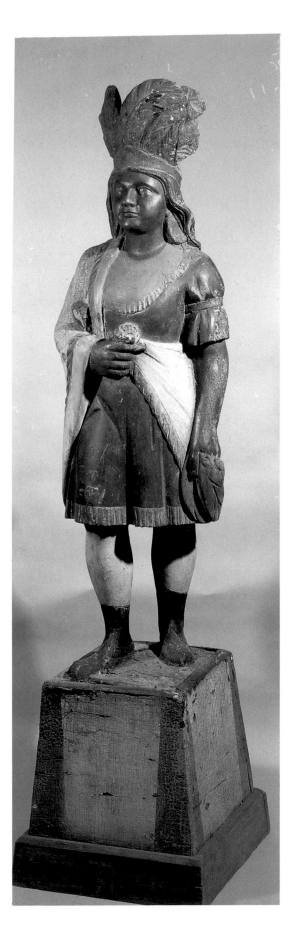

Rose Squaw Cigar Store Indian
Samuel Robb (1851–1928)
New York, 1877–80
Polychromed wood,
66½ × 17 × 19¼″
Gift of Sanford and
Patricia Smith

43

LOOKING AT THE E. FITTS, JRS. TRADE SIGN

Trade signs had to be noticed or they were of no use. The sign for E. Fitts, Jrs. General Store and Coffeehouse (see page 42) was decorated on both sides so that it delivered a message to passersby coming from either direction. The side shown here advertised the general store; the other side advertised the coffeehouse.

∽∽ The center of activity of a town was the general store. The shelves would be piled high with abundant supplies of goods—foodstuffs such as loaf sugar, tea, coffee, chocolate, pepper, salt, molasses, raisins, figs, butter, eggs, and flour, and many other commodities, among them bolts of fabric, ribbons, and laces. This sign depicts the well-stocked country store, showing off open shelves filled with all the goods a family could possibly need.

WHAT IS A CIGAR-STORE INDIAN?

The trade sign of the nineteenth-century tobacconist, who sold cigars and other tobacco products, was the cigar-store Indian, a carved and painted figure, usually of an Indian or an Indian squaw. But these cigar-store figures were not limited to representations of Indians. There were also soldiers, sailors, fashionable ladies, popular heroes, exotic foreigners such as Turks and Egyptians, and characters from literature.

Cigar-store Indians, often life-size figures, were placed at the front door of the tobacco shop. They were very heavy and were mounted on a base, usually equipped with wheels. This enabled the shopkeeper to move the figure outside in the morning and back inside when the shop closed at night.

HOW CIGAR-STORE INDIANS WERE MADE

Most cigar-store Indians were made by professional wood carvers in workshops located in the major cities. The cigar-store Indian shown on page 43 was made in the shop of Samuel Robb in New York. The Robb workshop employed many wood carvers and painters. They made a wide variety of advertising and trade figures, but they are best known for their cigar-store Indians.

A cigar-store figure was carved from a solid piece of white pine. The basic shape was outlined with paper patterns, and the form was then roughed out with a hand ax. Next, the carver used a chisel to refine the contours of the figure. The details of headdress and features were then carved with specialized tools. Raised or extended arms were made separately and attached with screws. After the carving was completed, the entire figure was sanded smooth and painted. The final step was to add the stand with wheels. These various steps in the shaping of the figure were executed by apprentices as well as master carvers, and another craftsman in the workshop probably did the painting.

The tobacco shops of the nineteenth century sold cigars, snuff, and other tobacco products. From the 1850s to the 1880s, there were so many cigar-store Indians that they caused traffic jams and impeded the progress of people walking along the crowded sidewalks. By the turn of the century, cigar-store Indians were banished from the streets and replaced by electric signs, which were effective even after dark.

∽∽ In looking at this Indian squaw, you will notice that she holds a rose in one hand and a tobacco leaf in the other. The rose is unique to this figure, but all cigar-store Indians held either a tobacco leaf or a cluster of cigars.

opposite:
Bicycle, Livery, Carriage and Paint Shop Trade Sign
Amidée T. Thibault (1865–1961)
St. Albans, Vermont,
c. 1895
Wood, Columbia bicycle,
84 × 66 × 36″
Gift of David L. Davies

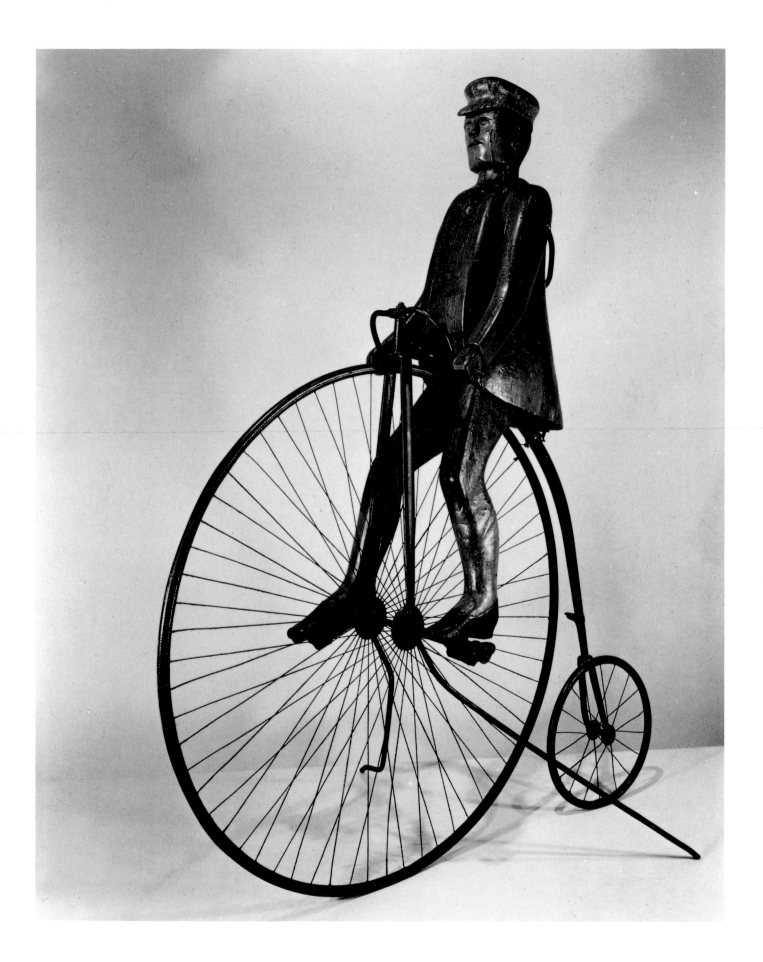

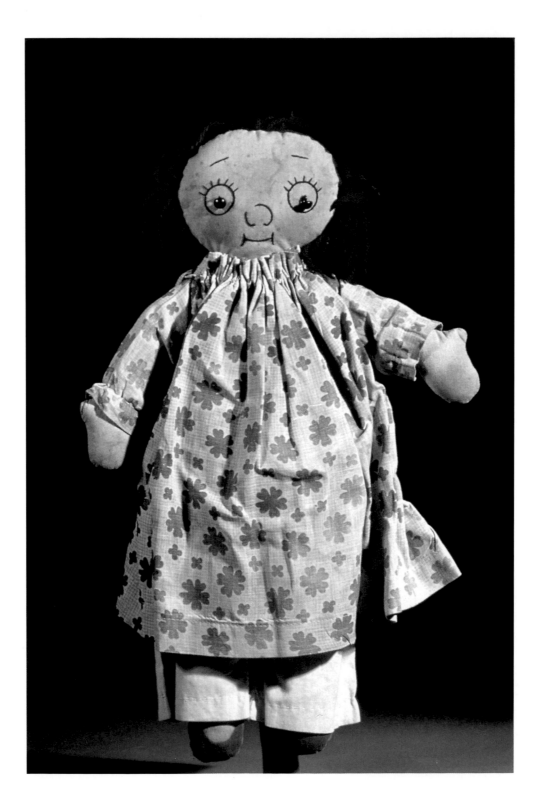

At Play

She was a beautiful doll. She had a face of white cloth with black button eyes. A black pencil had made her eyebrows, and her cheeks and mouth were red with the ink made from pokeberries. Her hair was black yarn that had been knit and raveled, so that it was curly. She had little flannel stockings and little black cloth gaiters for shoes, and her dress was pretty pink and blue calico.

—Laura Ingalls Wilder, *Little House in the Big Woods,* 1932

We played all the table games, such as checkers, chess, lotto, battledore, and shuttlecock, graces, vingt-et-un, cap and ball, Cormells, and the like.

—Edward Everett Hale, *A New England Boyhood,* 1893

DURING THE SEVENTEENTH CENTURY, children worked alongside their parents, preparing food and clothing for the family and maintaining the home and the farm. Children were considered miniature adults, but they, like their parents, had fun at community occasions like barn raisings, quilting bees, and the various holiday celebrations. Early American diaries tell of lively outdoor sports and games such as blindman's buff, hopscotch, jump rope, cricket, and a form of baseball. And even Puritan children, whose parents frowned on amusements and play, had a few treasured toys.

By the eighteenth century, children tended to be regarded as individuals in their own right, and playing with toys was recognized as an aid to learning. Using materials at hand—pieces of fabric from the scrap bag, bits of wood, metal, and leather—parents and relatives created pull toys, sewed stuffed animals, turned and painted rocking horses, whittled whistles, molded marbles, carved and painted dominoes, and incised and painted game boards for the enjoyment and pleasure of children.

The concept of play for play's sake finally took hold in the nineteenth century. Portraits of children during this time show boys and girls posing with a favorite toy: rocking horse, bow and arrow, doll, hoop, shuttlecock, kite, sailboat, rattle, ring, top, marbles, miniature china set, or pull toy. The Industrial Revolution set in motion a robust toy industry that continues to flourish. But it is the toys that were made by hand, created spontaneously and joyously from available materials, and carefully preserved at childhood's end, that have earned a place as folk art.

FOLK DOLLS

Dolls have always been a treasured part of childhood. Native Americans made dolls of corn husks long before the first settlers arrived from England. Though the early settlers worked from dawn until dusk, they found time to make dolls out of materials found at home—scraps of cloth or paper, pieces of wood, corn husks, clothespins, apples, nuts, wishbones, pinecones. These oddments were sewed, shaped, and painted into lovable companions—dolls that convey the essence of childhood.

opposite:
Raggedy Ann Doll
Artist unknown
Region unknown,
1910–20
Stuffed cotton muslin,
shoe buttons, yarn, ribbon-
embroidered features,
17 × 11¼ × 2⅜"
Gift of Anne Baxter Klee in
celebration of her mother

LOOKING AT THE RAGGEDY ANN DOLL

Raggedy Ann is probably one of the best-known and best-loved of American dolls. We can follow her story from the year 1914, when a little girl named Marcella Gruelle, rummaging in the family attic (in a house in Indianapolis), found an old rag doll that had been made by her great-grandmother. She took the faded, faceless doll to her father, an artist and writer, and with his pen he gave the doll a simple, one-line smile and a triangular nose and he stitched on two buttons for eyes. He also painted a red heart on her chest and beneath it printed "I Love You." Marcella named the doll Raggedy Ann, inspired by characters from James Whitcomb Riley's poems "The Raggedy Man" and "Orphan Annie." Sadly, in 1917 Marcella died, but her memory lives on in the series of more than forty books about Raggedy Ann that her father, Johnny Gruelle, wrote and illustrated, beginning with *Raggedy Ann Stories,* published in 1918. The first Raggedy Ann dolls were made to advertise this book in bookstores; millions more were mass-produced as Raggedy Ann won the hearts of American children. Many Raggedy Ann–inspired dolls were made at home, sometimes from printed patterns, sometimes from the imagination and memory of the maker.

The Raggedy Ann doll shown on page 46 was given to the Museum by the actress Anne Baxter and is thought to have been made around the time Raggedy Ann was "born." This doll differs slightly from the standard Raggedy Ann because she has a circular rather than a triangular nose and she is missing the freckle marks below the eyes.

You can create your own rag doll using the pattern and simple directions on pages 80–82 in the section Folk Art Projects (pp. 69–93).

LOOKING AT THE PAPER-DOLL SOLDIERS AND HORSES

Handmade paper dolls were popular playthings for children in the nineteenth century. Mostly, these paper dolls were portrait-like, reflecting the world of those days in fashions and hairstyles. The four paper dolls shown on page 49 are part of a set of forty-eight soldiers and horses. These soldiers in their splendid uniforms, with their plumed hats, sabers, rifles, and swords and their saddled and bridled horses, seem ready for battle. Generations of American children have been intrigued by toy soldiers—by the romance of their splendid uniforms and their deeds of gallantry and valor.

Folk art experts believe these paper dolls were cut out with fine scissors, or possibly a sharp blade, and painted with watercolors. If they were made by a child, it was probably with the help of an adult. Originally the soldiers and their horses were fitted with a backing of folded paper that enabled them to stand up as they moved through imaginary maneuvers.

GAME BOARDS

Before the advent of the phonograph and radio and television, games were the focal point of family evenings. Game boards of the nineteenth century were hand-crafted of wood and painted and stenciled with bold colors and ingenious geometric patterns. Many game boards had a suspension hook so that they could be hung on a wall when not in use. Students of folk art see in game boards design features that anticipate modern art of the twentieth century.

LOOKING AT THE CHECKERBOARD WITH CHECKER BOX

The checkerboard shown on page 50 has the necessary squares in contrasting colors. It also has wonderful painted designs: the tray depicts the night sky with stars and three phases of the moon at the bottom, and a brightly colored rising sun at the top. The design was the whimsy of the maker, named Osgood, and has nothing at all to do with the game of chess or checkers. But it is typical of a number of hand-painted game boards to have

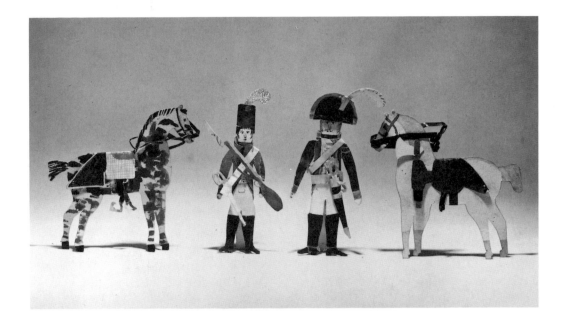

imaginative and creative designs like this one executed on the boards. It is thought that many of the game-board folk artists were sign painters as well, because designs from their signs are also found on game boards. A tin box was added to this game board for storing the checkers.

☞ You can try your hand at recreating this splendid game board for your own use. The directions are found on page 84 in the section Folk Art Projects (pp. 69–93).

WHAT IS A WHIRLIGIG?

A whirligig is a wind toy. Similar to a weather vane, a whirligig is a carved figure with moving parts powered by the wind. But the whirligig, unlike the weather vane, has no real use. Its purpose is simply to amuse and delight the viewer. There are two types of whirligigs, one inspired by articulated dolls and the other by windmills. A single-figure whirligig has propeller-type arms that move around in the wind. The more complex whirligigs have a figure or figures with many parts and are powered by a pinwheel-like propeller that catches the wind and, through an action of gears and rods, causes it to illustrate a specific action—ride a bicycle, saw wood, milk a cow. As the wind blows harder and harder, the whirligig moves faster and faster. These devices were often placed in front of old farmhouses, on a fence, in a garden, or on top of a roof. One of the earliest references to a whirligig in American literature appears in Washington Irving's 1819 story "The Legend of Sleepy Hollow": "Thus while the busy dame bustled about the house, or plied her spinning-wheel at one end of the piazza, honest Balt would sit smoking his evening pipe at the other, watching the achievements of a little wooden warrior, who, armed with a sword in each hand, was valiantly fighting the wind on the pinnacle of the barn."

LOOKING AT THE WITCH ON A BROOMSTICK WHIRLIGIG

Like weather vanes, whirligigs in American folk art come under the heading of sculpture. The body of the rather docile-looking witch shown on page 51 was carved from one piece of wood; it is simply formed and beautifully painted. The cleverly conceived broomstick with the propeller in front would turn faster and faster as the wind blew harder and harder. The propeller reminds us of the propeller on the first airplane, flown in 1903, some twenty to forty years after this whirligig was carved.

Soldiers and Horses Paper Dolls
Artist unknown
Boston, 1840–50
Watercolor and pen and ink on cut paper
Soldiers: 4 × 2″
Horses: 4 × 4¼″
Gift of Pat and Dick Locke

49

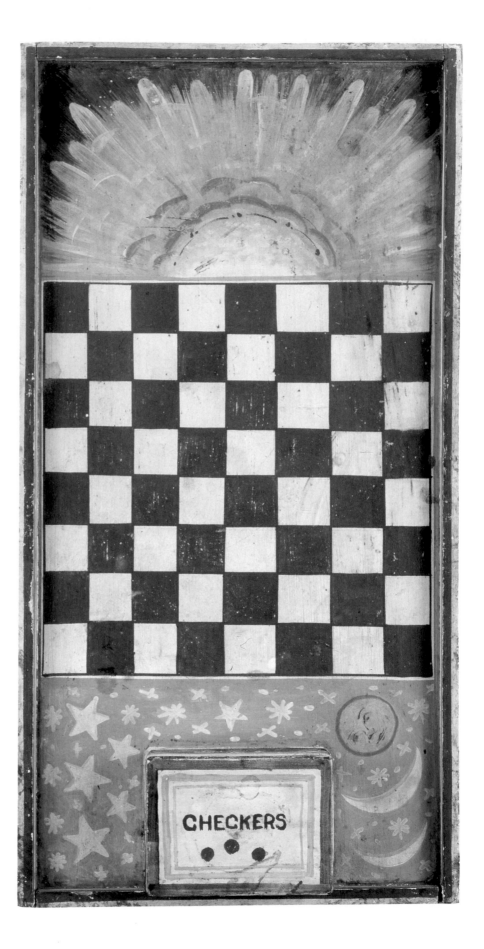

Checkerboard with Checker Box
Signed Osgood
Northeastern United States, late nineteenth century
Painted wood and tin, 21 × 10¾″
Promised gift of Patty Gagarin

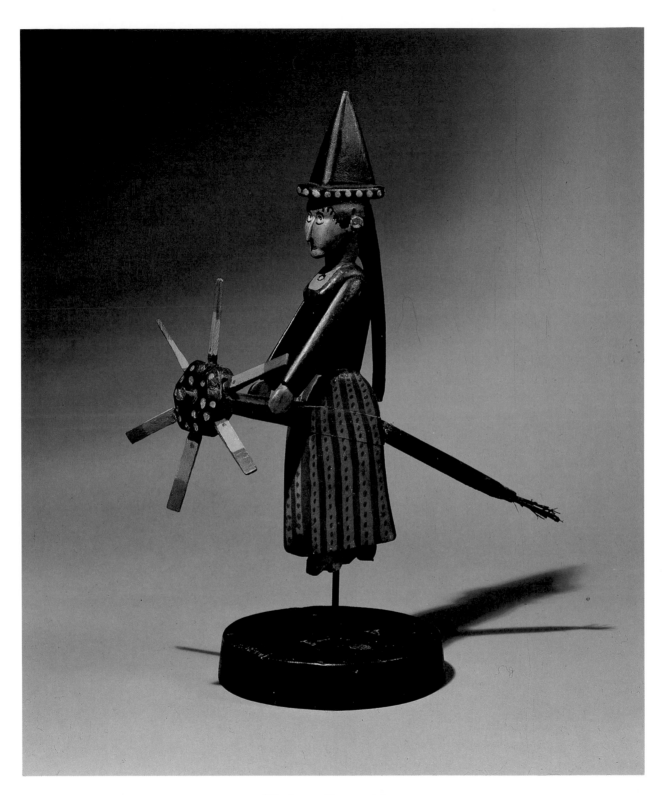

**Witch on a Broomstick
Whirligig**
Artist unknown
New England, 1860–80
Polychromed wood, twigs,
metal, 12¼ × 12¼ × 5¼"
Gift of Dorothy and Leo
Rabkin

MARTIN ANDRES was

born in Greenwich Township in Sussex County and
the State of West New Jersey the 1st day of February
Anno Domini 1788; His Father named Bernard Andres
and his Mother Mary Andres. Soon after his birth-
day he was Christian like baptized, his Godfather and
Godmother were his dearly beloved Parents ————

Whom have I in Heaven, but thee? and there is none upon Earth, that I desire
besides thee, my flesh and my heart falleth; but God is the Strength of my Heart
and my Portion for Ever. Psalm 73. Vers 25 & 26 ———

Family Traditions

The true character of Americans is mirrored in their homes.

—Médéric Louis Elie Moreau de Saint-Méry,
American Journey, 1773–1798

FOLK ART GIVES US insights into the way Americans lived, at home, in school, and at work. In folk art, too, we find evidences of how the rites of passage—marking birth, courtship and marriage, and death—were observed. Many of these family events and celebrations were commemorated in carefully designed objects whose origins were rooted in family tradition. Displayed in many American homes were hand-made and decorated dower chests and stitched and painted mourning pictures. Family Bibles and document boxes stored treasured birth and baptismal certificates, family records, valentines, and other family papers.

The arrival of a new child was recorded in a variety of birth and baptismal certificates, in family trees, and on family records. These announcements were commissioned by families and created by itinerant artists or local schoolmasters and ministers. The Pennsylvania Germans brought their own tradition of hand-inscribed and -painted documents to America. This particular body of American folk art is known as fraktur.

WHAT IS A FRAKTUR?

A fraktur is in fact an illuminated manuscript, and its ancestry can be traced back to the illuminated manuscripts of medieval times. Written in pen and ink in Gothic script and decorated with ornamental designs in watercolor, the fraktur is seen in a variety of forms, but the most common type is the birth and baptismal certificate like the one shown here.

The fraktur tradition came to America with the immigrants from Germany, Switzerland, and Alsace-Lorraine who settled in southeastern Pennsylvania during the late seventeenth century.

Most fraktur artists were schoolmasters or ministers. They did not sign their work, but students of folk art have identified a large number of them by their distinctive styles, observed over and over in examples of their work.

LOOKING AT THE BIRTH AND BAPTISMAL CERTIFICATE OF MARTIN ANDRES

John Spangenberg, a schoolmaster in Easton, Pennsylvania, and the creator of this fraktur, was referred to for many years, until his identity was established, as the "Easton Bible Artist." Spangenberg is known for the lively borders around his scripts. The out-

opposite:
Birth and Baptismal Certificate of Martin Andres
John Spangenberg, the "Easton Bible Artist" (before 1755–1814)
New Jersey or Pennsylvania, dated 1788
Watercolor and pen and ink on paper, 15½ × 13″
Promised anonymous gift

Heart and Hand Valentine
Artist unknown
Possibly Connecticut,
1840–60
Cut paper, varnish, pen
and ink, 14 × 12″
Museum of American Folk
Art purchase

**Stephen Hall–Catharine
Mayberry Family Record**
"Heart and Hand Artist"
Casco, Maine, dated
Sept. 12, 1850
Watercolor and pen and
ink on wove paper,
13½ × 9¾″
Gift of Mr. and Mrs. Philip
M. Isaacson

**Mourning Picture for
Mrs. Ebenezer Collins**
Probably Lovice Collins
South Hadley,
Massachusetts, 1807
Watercolor, silk thread,
metallic chenille thread on
silk, pencil on paper label,
diameter 17"
Eva and Morris Feld Folk
Art Acquisition Fund

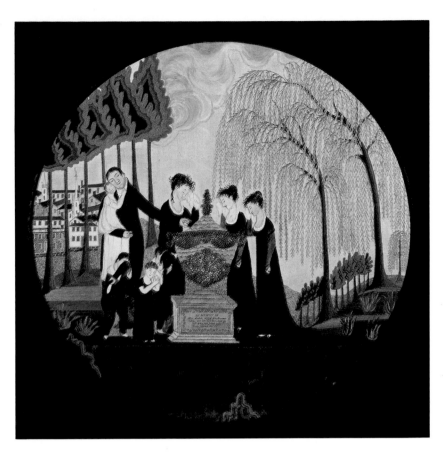

**Dower Chest with
Mermaid Decoration**
Artist unknown
Pennsylvania, dated 1790
Painted and decorated
pine, iron,
24¾ × 50½ × 23¾"
Museum of American Folk
Art purchase

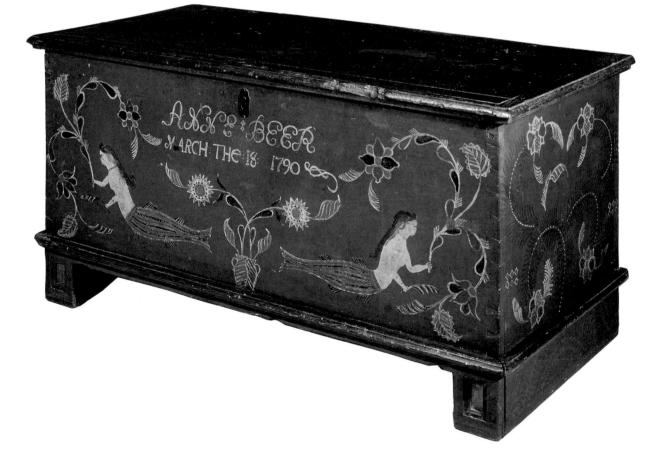

sides of his fraktur are filled with flowers and captivating figures, among them a number of musicians.

Birth and baptismal certificates commonly give the following information: the name of the new arrival, the names of both parents (including the mother's maiden name), the date and place of birth (often with hour of birth and zodiacal sign), the date of baptism, the name of the baptizing pastor and the sponsor, and verses from the Bible. Some certificates may have been framed and hung in the house as decoration, but most were kept between the leaves of the family Bible or were pasted inside the lid of a blanket chest.

ⴲⴲⴲ Look at the Birth and Baptismal Certificate of Martin Andres (see page 52). There are two interesting details about this certificate: first, it is written in English, whereas almost all others at this time were written in German; second, the place of birth is given as "the State of West New Jersey."

☞ You can create a birth certificate for yourself or make one for a new baby, using the directions on page 92 in the section Folk Art Projects (pp. 69–93).

LOOKING AT THE STEPHEN HALL—CATHARINE MAYBERRY FAMILY RECORD

Popular at the end of the eighteenth century and well into the nineteenth, family records were inscribed and painted in a variety of styles by schoolmasters and itinerant artists.

The family record shown on page 54 was the work of an itinerant painter who is known to have worked in Maine, Vermont, and New Hampshire from 1830 to 1856 but whose identity is still obscure. As we have seen, a folk artist who is not yet identified is often given a working name based on a specific characteristic of the work or the location associated with it. Experts have named the artist of this family record, and of others like it, the "Heart and Hand Artist" because of the distinctive use of the heart and hand motif.

ⴲⴲⴲ One family record by this artist is signed, but in an elusive manner. Only by holding a mirror up to the signature can one make out the name Samuel Lawhead (or Lawhend). Further research is needed to confirm the link between Samuel Lawhead or Lawhend and the "Heart and Hand Artist."

While this family record does not contain the heart and hand motif, it is consistent with other works by the "Heart and Hand Artist." His family records have a simple list of names and dates in columns, framed with scalloped and draped borders. Hearts surround a wedding date, and sometimes weeping willows and tombstones surround a date of death.

LOOKING AT THE HEART AND HAND VALENTINE

The inscription on one of the cut-paper hearts (see page 54) in this valentine says:

> *"Hand and heart shall never part*
> *When this you see*
> *Remember me."*

This heart and hand motif may have evolved from the English custom of a man giving a gift of gloves to the woman of his choice on Valentine's Day, accompanied by this verse:

> *"If that from Glove, you take the letter G,*
> *Then Glove is Love and that I send to Thee"*

The gift of a pair of gloves served as a marriage proposal. If the young woman accepted, she wore the gloves to church on Easter Sunday. Perhaps this heart and hand valentine was inspired by a similar desire and intent.

☞ You can weave a heart into a hand for your own valentine by following the directions on page 87 in the section Folk Art Projects (pp. 69–93). Before the nineteenth century, it was customary in America to send valentine-like tokens of love any day of the year, not just on Valentine's Day. So send off your heart and hand to someone you like as soon as you complete it.

WHAT IS A DOWER CHEST?

A dower chest was designed to hold the household linens that a young woman began to collect as a girl in anticipation of the day when she would marry and set up housekeeping. The chests were usually decorated with painted designs and inscribed with the owner's name and a date.

LOOKING AT THE DOWER CHEST WITH MERMAID DECORATION

As new immigrants arrived in America, they brought their family traditions with them. Among Pennsylvania Germans it was customary to provide a dowry for a daughter. Girls were given dower chests by their parents to hold the quilts and linens they would accumulate for their new home.

〜 Dower chests were made by local joiners, and they were often painted and decorated by itinerant artists, sometimes the same artists as created frakturs. Others were painted by amateurs using paper patterns to copy traditional motifs—mermaids, tulips, peacocks, roses, and pinwheels. The dower chest on page 55 is inscribed: "Anne Beer March the 18 1790." If you look carefully you'll discover that the bottom drawer of this chest is missing.

WHAT IS A MOURNING PICTURE?

From the death of George Washington, in 1799, until the mid 1820s, it was a widely observed custom to create pictures as memorials. Memorial art was not limited to painting, but included needlework and even jewelry. The iconography of mourning—images of urns, monuments, willows, and weepers—was popular, and these forms were cut into stone, carved on furniture, pressed into brass drawer pulls, and woven into textiles.

To honor departed loved ones, silk-embroidered mourning pictures were made by relatives or close family friends, and many were made by schoolgirls in honor of relatives they may never have known. Along with samplers and theorem paintings, mourning pictures were part of the curriculum at the academies and finishing schools where families with financial means sent their daughters to learn the polite arts of needlework, music, dancing, writing, and watercolor painting.

LOOKING AT THE MOURNING PICTURE FOR MRS. EBENEZER COLLINS

This mourning picture (see page 55) was probably stitched by Mrs. Collins's daughter, Lovice, at Abby Wright's school in South Hadley, Massachusetts. The picture depicts each of Mrs. Collins's seven children. Mrs. Collins died in 1805, when she was only thirty-eight years old, according to the inscription on the base of the urn. Her seven children and husband appear in attitudes of mourning around the tomb.

〜 A number of materials and techniques aside from the stitching were used to create this picture; notice that the sky, the village in the background, and the figures of the family were painted in watercolors, the epitaph is inscribed on the base of the urn, green velvet was appliquéd on the lower part of the picture, and silver metallic braid was added to the sparkling tomb.

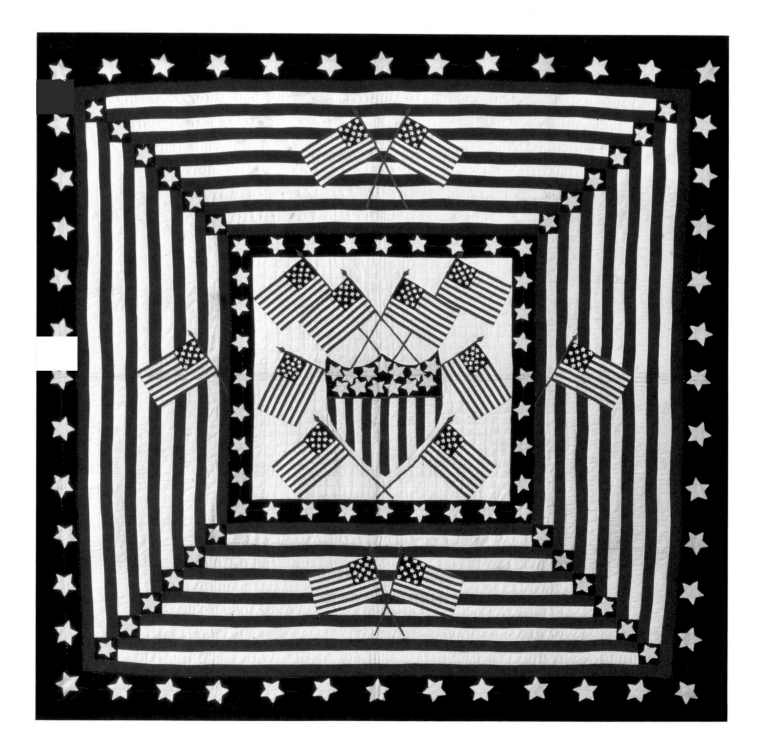

Celebrating America

We were taught every day and in every way that ours was the freest, the happiest, and soon to be the most powerful country in the world.... We read it in our books and newspapers, heard it in sermons, speeches, and orations, thanked God for it in our prayers, and devoutly believed it always.

—Thomas Low Nichols, *Forty Years of American Life,* 1864

Aᴿᴛᴇʀ ᴛʜᴇ ʀᴇᴠᴏʟᴜᴛɪᴏɴᴀʀʏ ᴡᴀʀ, as Americans celebrated their new nation, there was a swelling tide of patriotism. National pride was more intense than can be imagined today. Americans had a sense of boundless opportunity and enormous confidence in the future. The victory over the English in the War of 1812 reinforced this pride; Americans had won a "second War for Independence," which established their country as a world power. Then in 1876, with the Centennial celebrating America's 100th birthday, a new generation became caught up in the patriotic fervor.

Americans' exuberant faith in their country was nourished by the stories and poems they heard in their homes, in their schools, and at political and religious gatherings. This love of country is reflected in the paintings, sculpture, needlework, and pottery of American folk artists. A whole vocabulary of patriotic symbols has evolved, among them the American flag in all its versions, the bald eagle, Uncle Sam, and Miss Liberty. American leaders became folk heroes, and George Washington, Benjamin Franklin, Abraham Lincoln, Theodore Roosevelt, John F. Kennedy, and Martin Luther King, Jr., were not only honored in prints and paintings hung in schools, office buildings, and homes but were also depicted on many household objects.

THE FLAG

There were many different "American" flags flown during the Revolutionary War. The first step in the standardization of the flag was taken in 1777, on June 14 (now observed as Flag Day): Congress adopted a resolution "that the flag of the thirteen United States be thirteen stripes alternate red and white; that the union be thirteen stars, white on a blue field, representing a new constellation."

Flag makers differed in the way they interpreted this enactment. Some arranged the thirteen stars in a circle in the blue field, others arranged the stars in an oval, still others arranged them in straight lines. The early stars were five-pointed, six-pointed, even seven- and eight-pointed, depending on the maker. Between 1794 and 1818, the flag contained fifteen stars and fifteen stripes because of the admission to the Union of two new states. It was soon realized that many more states would apply for statehood, and in 1818 Congress passed a law restoring the thirteen stripes denoting the thirteen original colonies and providing that a star be added for each new state admitted to the Union.

opposite:
Commemorative Patriotic Quilt
Mary C. Baxter
Kearney, New Jersey,
c. 1898
Cotton, 76 × 78"
Gift of the Amicus Foundation, Inc.,
Anne Baxter Klee, and
Museum Trustees

Flag designs were popular with folk artists. They were incised in pottery, hammered into the sheet metal of weather vanes, woven into Indian blankets, painted on boxes and trade signs, and even, as we have seen, used on a gate. The flag was also a favorite motif stitched with patriotism and pride into bold and colorful quilts.

LOOKING AT THE FLAG QUILT

The flag quilt shown on page 58 is an excellent and graphically successful example of its type. An unmistakable energy is conveyed by the creative use of the elements of the flag. As you look at the quilt, you will notice that it was designed as variations on the theme of the flag. The outer frame of navy stripes with thirteen stars on each side, the red and white stripes, the five-pointed stars on a navy background—it is the elements of the flag that give this quilt strength and beauty.

The making of flag quilts increased during times of national crisis and triumph. According to oral tradition, the Spanish-American War (February–August 1898) was the inspiration for the making of this flag quilt. And the admittance of a state into the Union was always an occasion that turned the minds of quiltmakers toward the flag theme.

UNCLE SAM

The character of Uncle Sam was "born" during the War of 1812, but it is a painter, illustrator, and political cartoonist named Thomas Nast (1840–1902), who is credited with creating the Lincolnesque version that is popular today.

Originally, there had been a real Uncle Sam—a man named Sam Wilson, who owned a meat-packing business in Troy, New York. During the War of 1812, besides being a provisions inspector, he had a government contract to supply meat to the troops stationed near Troy. He stamped all the barrels with the initials U.S., indicating that the beef was the property of the United States Government. (Until this time, "U. States" had been the common abbreviation.) Sam Wilson, a well-liked man, was affectionately called "Uncle Sam" by family and friends, and workers are said to have read the "U.S." stamped on supplies as a short form of his nickname. The term developed into an American legend.

The concept of Uncle Sam was fully developed during the Civil War and the postwar period. It was during these years that Thomas Nast gave Uncle Sam the tall, thin, hollow-cheeked, and bearded presence reminiscent of Abraham Lincoln. By 1900, Uncle Sam was firmly entrenched as the symbol of the republic.

LOOKING AT THE UNCLE SAM WHIRLIGIG

In this late-nineteenth- or early-twentieth-century whirligig (see page 62), Uncle Sam pedals a bicycle with a propeller on the front that catches a breeze strong enough to flutter the flag behind him. The artist, while capturing Uncle Sam's traditional dignified demeanor, succeeds in conveying the whimsical aspect that is also typical of the character. Uncle Sam's posture is erect and stately and his expression serious, but we cannot but be amused by the spectacle of his long legs pedaling round and round. He is dressed in formal clothes, but here too, in their embellishment with stars and stripes, there is a slightly comic air. Uncle Sam is a charming and captivating American image.

The flag behind Uncle Sam in this whirligig is American on one side, Canadian on the other. It is logical to deduce that the maker of the whirligig may have been a transplanted Canadian or an American who lived near the Canadian border and wanted to please all his neighbors.

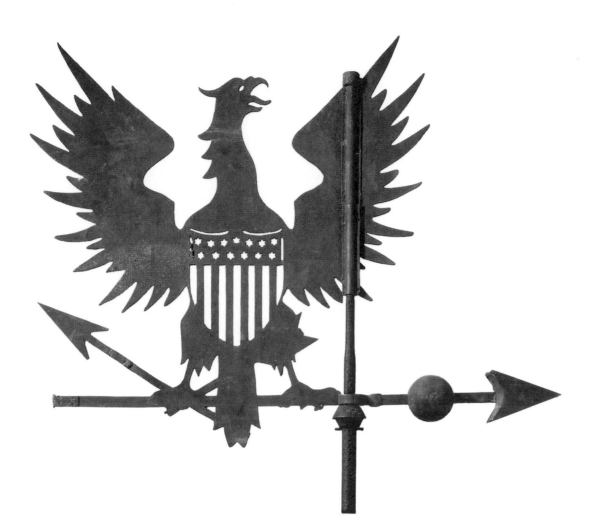

THE BALD EAGLE

The American bald eagle, featured on the Great Seal of the United States, has been a favorite motif of folk artists ever since the seal was adopted by Congress, on June 20, 1782. The eagle became the official symbol of the United States after a six-year search for a design for the seal, during which Benjamin Franklin is said to have suggested that the turkey be the symbol for the new country!

The eagle is a time-honored symbol of independence, freedom, and strength. It was the symbol of Jupiter, who is identified with the Greek Zeus, the mightiest of the Olympian gods. The Native Americans consider the eagle sacred. As we have seen, the double-headed eagle, used in Austria and Germany, is found on the pottery and other forms of folk art created by the Pennsylvania Germans in America.

LOOKING AT THE EAGLE WITH SHIELD WEATHER VANE

Most folk artists carved three-dimensional eagles as seen in nature, but this cut-out weather vane depicts the eagle with a shield covering its breast, like the eagle in the Great Seal of the United States. Yet this eagle seems ready to declare its independence and fly off with its strong, oversize, powerful wings. Eagle weather vanes were used on government buildings, town halls, and community houses.

ᏬᎣᏬ The Great Seal of the United States appears on the one-dollar bill. If you compare the eagle on the back of a dollar bill with the eagle on this weather vane, you will find several differences, but the weather vane eagle, with its strange froglike legs and

Eagle with Shield Weather Vane
Artist unknown
Massachusetts, 1800–10
Cast bronze, 36 × 43½″
Gift of Mr. and Mrs.
Francis S. Andrews

61

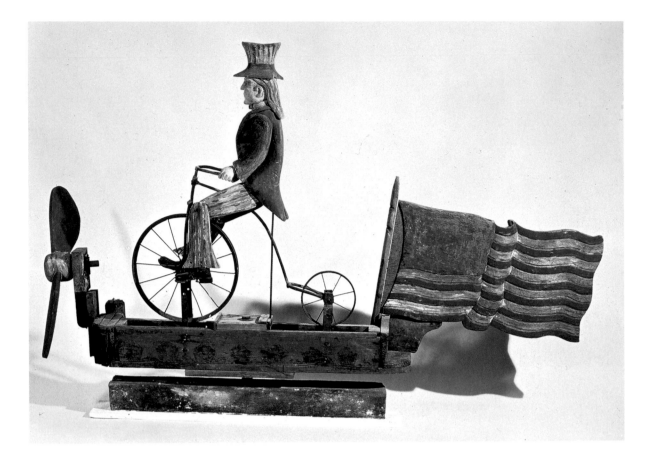

Uncle Sam Riding a Bicycle Whirligig
Artist unknown
Northeastern United States, 1880–1920
Carved and polychromed wood, metal,
37 × 55½ × 11″
Promised bequest of Dorothy and Leo Rabkin

opposite:
General Washington
Artist unknown
Southeastern Pennsylvania, c. 1810
Gouache, watercolor, and pen and ink on paper,
9¾ × 8″
Promised anonymous gift

long, gawky neck, is similar to the phoenix-inspired eagle in the Great Seal. The six-pointed stars used on the weather vane eagle's shield are typical of the stars favored in the last years of the nineteenth century. Do you see any other differences?

PATRIOTIC FOLK HEROES: GEORGE WASHINGTON

"First in war, first in peace, first in the hearts of his countrymen," George Washington came to personify the republic. As Commander of the United States Army during the Revolutionary War he had been a beloved hero. As President, he steered the course of the nation. And the human qualities of this great leader were the subject of folk tales, like the story about his honesty in regard to the chopping down of the cherry tree. Because of his importance as a folk hero, Washington's likeness was painted, stitched, sculptured, and drawn over and over in American folk art. He was a symbol of the American ideals of independence and liberty.

LOOKING AT *GENERAL WASHINGTON*

This painting is in the Pennsylvania German fraktur tradition, combining brightly colored watercolor drawings and handwritten script. The two-line inscription, in German, translates as: "General Washington and the city built in his name." The grand domed building directly behind Washington, labeled "Con Gress Housae," depicts the House of Congress as it appeared in 1800.

Notice that the artist emphasizes Washington's importance by adding gold sparkles to his epaulets, to the buttons on his jacket, and to the buckle on his hat. And a fact not lost on this folk artist is that throughout the history of art, artists have depicted important leaders on horseback.

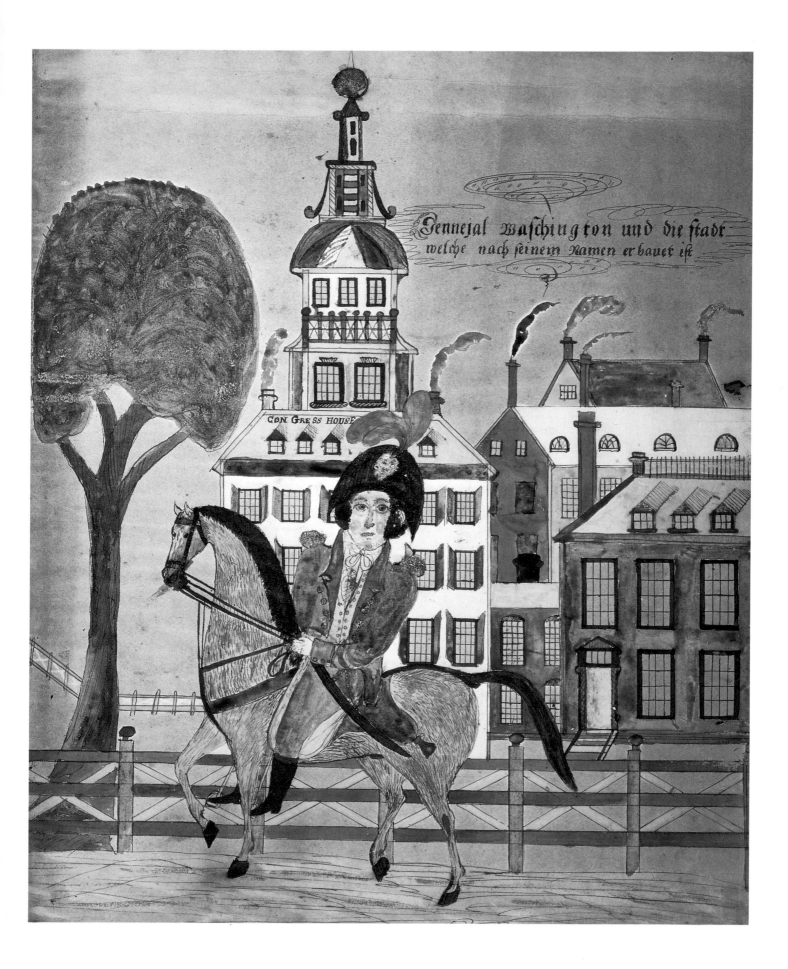

CHAPTER TEN Twentieth-Century Folk Art

In 1976 I begin folk art painting and I don't think I will ever quit because I find no end to folk art painting and I don't think no artist on earth found the end of art.

—Howard Finster, quoted in J. F. Turner, *Howard Finster: Man of Visions,* 1989

THE WORK OF MOST American folk artists of the twentieth century looks very different from that of the crafts people, painters, and carvers of the eighteenth and nineteenth centuries. Folk art is always an expression of its own time and locale. Folk artists are inspired by the political events taking place around them, by religious beliefs, and by popular heroes. Their artistic style is drawn from books and newspapers, illustrated magazines, postcards, advertisements, and photographs. Nowadays, inspiration also comes from sources like television, space travel, and current issues such as civil rights. Trends in formal art also influence the folk artist. While folk art of earlier centuries consists mainly of objects for daily use, the works of twentieth-century folk artists, for whom most everyday necessities are easily available, consist mainly of paintings, drawings, sculpture, and textiles.

While there are visual differences in their works, living folk artists share many of the same impulses as led folk artists of the past to carve whirligigs, stitch quilts, and paint landscapes. Intuitively, all these folk artists have mastered the elements of color, form, composition, and texture to create art that is original, fresh, and enduring. Like the folk artists of the past, today's folk artists use the materials at hand. A sculptor carves animals from wood found in nearby forests or intertwines twigs and branches to form human shapes. Painters in this century use discarded cardboard or wood panels, masonite, Plexiglas, or paper as their "canvas." Oil paint is as common as acrylic and tempera paint, enamel, poster paint, crayon, oil pastel, house paint, and radiator paint. Found objects—such as pieces of glass, bottle caps, rags, marbles, television cables, straw from brooms—are used in creating art and in decorating sculpture and painting. Indeed there are "environmental" artists who use found objects to create large structures, towers, and fountains that cover acres of land.

As we have seen, the folk artists of the eighteenth and nineteenth centuries mostly had no academic training in art. Like them, the living folk artists of this century often have no formal art education. Twentieth-century folk artists come from all walks of life and varied ethnic backgrounds and tend to live in communities outside the mainstream.

Various terms are used to describe twentieth-century folk artists. Referred to as "visionaries" are those who say their paintings are inspired by God and grow out of their dreams or visions. Another group of folk artists are called "memory painters." These artists often come to painting late in life and paint scenes depicting their childhood as they remember it. Some twentieth-century folk art is known as "outsider art."

opposite:
Neil House with Chimney
William Hawkins (b. 1895)
Columbus, Ohio, 1986
Enamel and composition
material on Masonite,
72 × 48″
Gift of Warner
Communications Inc.

This term covers paintings and sculpture created in urban or rural isolation by people who not only have not attended art school but may have had little formal education. These folk artists may be recluses or even be confined to institutions or prison.

Unlike the greater number of folk artists of earlier centuries, most twentieth-century folk artists are known by name. They almost always sign their works. Not only their names but their ages and the locations where they paint and work are ascertainable. Oral or written biographies are recorded on videotapes, tape recorders, in diaries, and in other sources. Knowing about artists' lives is an aid to understanding and appreciating their art.

LOOKING AT *A DIVIDING OF THE WAYS* BY GRANDMA MOSES

Grandma Moses is the best-known of the twentieth-century folk artists. She began painting the pictures that have made her famous when she was in her early seventies, after her husband had died and her children were grown. Grandma Moses belongs to the group referred to as "memory painters" because her works seem to be inspired by her remembrance of daily life on the farm of her childhood. Grandma Moses recalled painting in school as a young child and being praised by her teachers for her talent, but she did not resume painting until late in life, when she was freed from the daily chores of managing a farm. Most of her paintings are landscapes and scenes of everyday life on a farm in rural New York State. Because her scenes emphasize neither the background nor the foreground, her works are almost quiltlike renderings of landscape. They often depict the many activities of a number of people and are composite panoramas of events extending over many days.

Grandma Moses painted actively until she was 101 years old. She lived to see her work win national and then international acclaim. This recognition meant that painting was no longer a hobby; it became a full-time occupation. Yet she was never concerned with celebrity status or with following trends. "If people want to make a fuss over me, I just let 'em, but I was the same person before as I am now," she said after a trip to a gallery opening in New York. Grandma Moses was a practical, thrifty farmer, and despite the success of her paintings she still thought about making ends meet. "If I didn't start painting, I would have raised chickens," she said, "I would never sit back in a rocking chair waiting for someone to help me." Painting was the way she continued to help herself and her family until her death, in 1961.

๑๏๛ Looking at Grandma Moses' painting *A Dividing of the Ways,* can you discern the influence of popular prints, greeting cards, and calendars? The painting certainly is a joyful depiction of a perfect winter day. Grandma Moses generally signed her paintings "MOSES." Can you find her signature?

LOOKING AT *DELTA PAINTING* BY HOWARD FINSTER

Of the folk artists described as "visionaries"—those whose paintings are depictions of creations of imaginary or fanciful visions or dreams—the Reverend Howard Finster is one of the best-known.

A former preacher living in Georgia, Howard Finster has created more than ten thousand works. He began painting in 1976, responding to a vision that inspired him to pick up a paintbrush and a can of tractor enamel and "paint sacred art." Finster's painting style grew out of the drawings he made on chalkboards to illustrate his sermons and teaching. His paintings are filled with drawings and with Bible verses and original poetry. "I don't go by ideas or books," Finster says, "I go by visions. . . . If I have a new vision, it will bring new art. I've got a lot of visions of art that I've never drawn yet." Finster says he is driven to paint by a sense of his responsibility to bring his teachings and

messages to as many people as he can. Finding that his paintings are viewed by many more people than listen to his sermons, Howard Finster has replaced his preaching with painting.

ᚼᚱᛟ Looking at *Delta Painting,* can you find the message, "Anough People in the World to hold things together if they would only pull together"? The artist says his mind is always filled with ideas, words, and inspirations. Read the other messages, and find the date the painting was created.

LOOKING AT *SEATED TIGER* BY FELIPE BENITO ARCHULETA

Felipe Benito Archuleta of Tesuque, New Mexico, is well known for his witty and whimsical carved and painted animals. At the age of fifty-four, Archuleta was inspired, after praying to God for guidance in his life, to begin carving. His wood carving is thought to have grown out of the Spanish tradition of carving. Three-dimensional figures of saints were carved and placed in missions and chapels by the colonists and natives beginning in the sixteenth century, when the Spanish settled in New Mexico.

Using the local cottonwood, Archuleta shaped the animal roughly with a chain saw, then chopped it down to form with an ax. With chisel, saw, and knife he whittled the features and other details. Then the animal was sanded and painted with common house paint. Like many other twentieth-century folk artists, Archuleta was inspired both by nature and by fantasy.

Archuleta, who died in December of 1990, worked with his son, Leroy, and his grandson, Ron Rodriguez, carving animals. The popularity of these artists extends beyond the United States, to Europe and elsewhere in the world.

ᚼᚱᛟ This tiger is about the size of a large dog. Archuleta usually signed and dated his animals underneath the base of the sculpture, but for some reason he placed the year in which this tiger was made where it could be seen more easily. Can you find it?

Folk art is for us all to enjoy. You will find folk art not only in museums but in many other places—in books, in art galleries, at country fairs, and at antique shows. Indeed you may come upon folk art at a street fair or an outdoor art show, in your own attic, or in your neighbor's garage.

The adventure of discovering American folk art opens up new ways of thinking about artistic expression and enables us to view America's past through a different lens. As you study the works of folk art in the Museum's collection and endeavor to create works similar to them, you will gain a broader understanding of the history and complex nature of this fascinating subject.

Folk art is hard to define, but it reaches out to us in a special way. These works are beautiful, amusing, and often touching. They remind us how deep is the human impulse to decorate. The untrained, often anonymous, folk artists were ordinary people; generally the art they created was designed, produced, and consumed in and for their own community. Giving free rein to their imagination and creative bent, they brought beauty into their everyday lives.

Thus the study of folk art can be an inspiration to us. We are attracted to a work of folk art by the maker's use of line and color and by the blending of the various elements into a pleasing composition. But we also ask the discovery questions: Who created it? When? Where? Why? What is it made of? What story does it tell about the maker? And these questions cannot help but stimulate our own impulse to imagine and to create—an impulse that can enrich us throughout our lives.

opposite:
Seated Tiger
Felipe Benito Archuleta
(1910–1990)
Tesuque, New Mexico,
dated 1970
Cottonwood, paint, gesso,
30¾ × 16¾ × 35″
Gift of Elizabeth Wecter

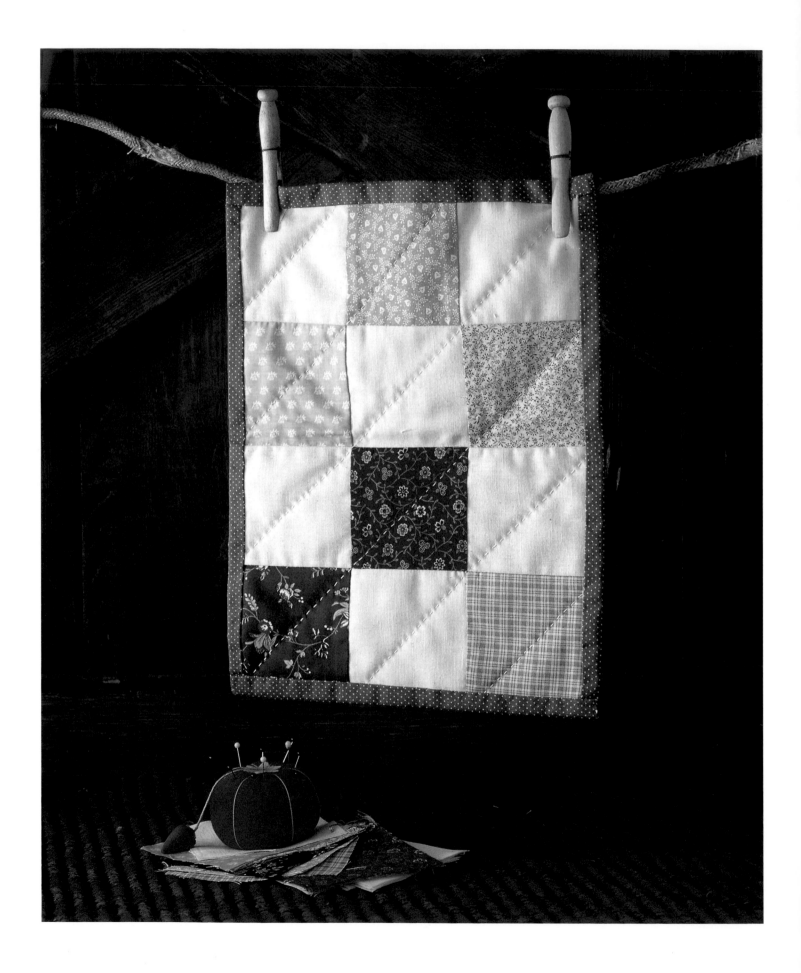

One-Patch Doll Quilt

This easy-to-make doll quilt can be hand- or machine-sewn. It is made from twelve 4″ squares of printed and plain fabric (we made six of the squares from plain muslin), backing fabric, and batting.

MATERIALS:

assorted print and plain fabric scraps, each
* at least 4″ square*
backing fabric 13 × 16½″
batting 11 × 14½″ (low-loft polyester)
cardboard
scissors
straight pins
thread (white)
needle, or sewing machine
iron, ironing board

TO BEGIN:

1. Trace and cut out the 4″ square pattern. Draw around it on cardboard, then cut it out to use as a template.

2. With a pencil, trace around your cardboard template on the fabrics of your choice. Cut out twelve squares, carefully following the pencil lines.

3. On a flat surface align the twelve squares into four rows of three each. Arrange them until you like the way they look.

TO SEW:

1. Start with the top row of squares: Put the left square on top of the middle square with the right sides of the fabric facing.

2. Pin these squares together along one side edge, and sew together with a 1/4″ seam. If sewing by hand, use backstitch or a small running stitch. You can mark the seam line with pencil if you wish.

3. Open up the squares and place them face up. Then place the right square over the middle square with the right sides of the fabrics facing.

4. Pin and sew the right square to the middle square along the edge opposite the first seam. Put aside.

5. In the same way, sew together the three squares in the second row, then the third row, then the bottom row.

6. With the wrong side of the fabric facing up, iron all seams flat.

7. To connect the rows, place the top row

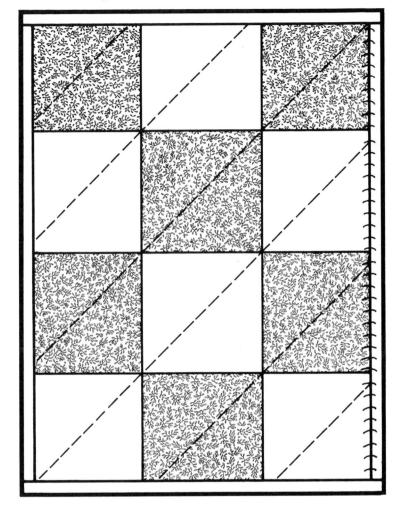

DIAGRAM FOR DOLL QUILT

on top of the second row, right sides of fabrics facing. Pin and sew along one long edge. Then sew the second row to the third and the third row to the bottom row. With the wrong side of the fabric facing up, iron all the seams flat. This is the quilt top.

TO FINISH:

1. Place the backing fabric wrong side up on the ironing board.

2. Place the batting on top of the wrong side of the backing fabric so that 1″ of the fabric is showing all around.

3. Put the quilt top on the batting with the right side facing up.

4. Pin all three layers together.

5. With needle and thread, sew lines of small running stitches through all the layers

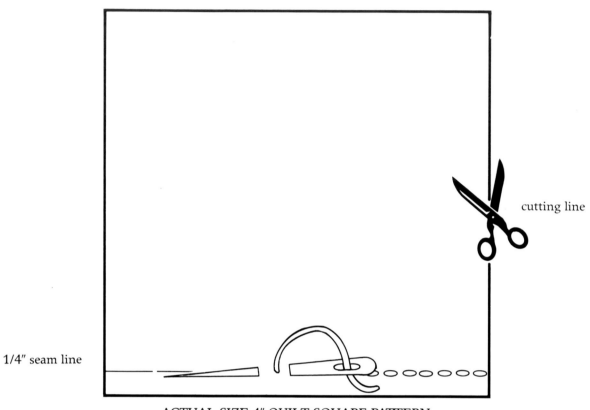

1/4" seam line

cutting line

ACTUAL-SIZE 4" QUILT SQUARE PATTERN

from the top right corner of each square to the bottom left corner. This is the quilting.

6. Fold the backing fabric over the sides of the quilt top, turning the edge under ½". Pin all around and sew together, using an overcast stitch.

The finished quilt size is approximately 11 × 14½".

Guide to Stitches

RUNNING STITCH:
These are small stitches made by bringing the needle in and out of the fabric in a straight line. The size of the stitches and spaces between them should be the same. Use this stitch to make quilting lines.

BACKSTITCH:
Take the first stitch like a running stitch, bringing the needle up as if to take a second stitch. Instead of taking the next stitch forward along your sewing line, take it back to meet your first stitch. Bring the needle up along the sewing line one stitch-length forward of the second stitch, then back to meet the second stitch. Continue in the same manner. The stitches are twice as long on the back. Use this stitch to sew the quilt squares together.

OVERCAST STITCH:
Take small slanted stitches, inserting the needle through the folded edge of the backing fabric and the quilt top.

Use this stitch to sew the backing fabric to the quilt top.

RUNNING STITCH

BACKSTITCH

OVERCAST STITCH

Basket, Fruit, and Butterfly Theorem Painting

This theorem painting is a still life stenciled on fabric. Details like curly vines and butterfly antennae are added last, with a fine-point marking pen. Tea-dye the fabric for an antique look.

MATERIALS:

large flat pan
2 tea bags
sturdy cotton duck or canvas fabric 10 × 12"
tracing paper
white wax stencil paper
stencil brushes #4 or #6, one for each color
 (or rinse and dry brush after using each
 color)
craft knife, such as an X-acto
masking tape
pencil
newspaper or cutting mat
small jars or squeeze bottles of acrylic paint:
 brown, green, red, yellow, orange, purple
plastic plates
fine-point brown marking pen

TO TEA-DYE:

1. Steep two tea bags in two cups of hot water.
2. Let cool slightly and pour into the large, flat pan.
3. Immerse fabric in tea until it turns the desired color. Tea stains very quickly!
4. Rinse and dry the fabric, then press.

TO MAKE THE STENCILS:

1. Using the tracing paper and pencil, trace the patterns for the shapes from the book.
2. Tape the traced patterns to a window-pane. Tape a piece of stencil paper over one shape, making sure it is 2" larger all around that shape.
3. Using the pencil, trace the shape onto the stencil paper. In the same way, trace the rest of the shapes onto stencil paper.
4. Place a thick layer of newspaper or a cutting mat on your worktable. Using the knife, carefully cut out each stencil design.

TO STENCIL-PAINT:

1. Tape the fabric to your worktable.
2. Place the basket stencil on the fabric first, with the bottom of the basket centered and 2" up from the lower edge of the fabric.
3. Squeeze a little brown paint onto a plastic plate. Dip the tip of a dry stencil brush lightly into the paint. Tap the brush up and down on newspaper or paper towels to remove excess paint. To work best, the brush should have very little paint on it.
4. Holding the stencil in place with one hand, use an up-and-down tapping motion with the stencil brush to paint the cut-out areas of the stencil. Paint around the edges first, then fill in the center of each area. Paint as lightly or as densely as you wish.
5. Lift the stencil right after you have painted in all areas of the basket. Let the paint dry.
6. In the same way add the other stencil shapes, one at a time. Let the paint dry after adding each shape, and rinse and dry the brush between colors.
7. After all the paint is dry you can add fine, curly tendrils to the grapes, antennae to the butterfly, and other details as you wish, using a fine-point marking pen. You may want to sign your name, too.

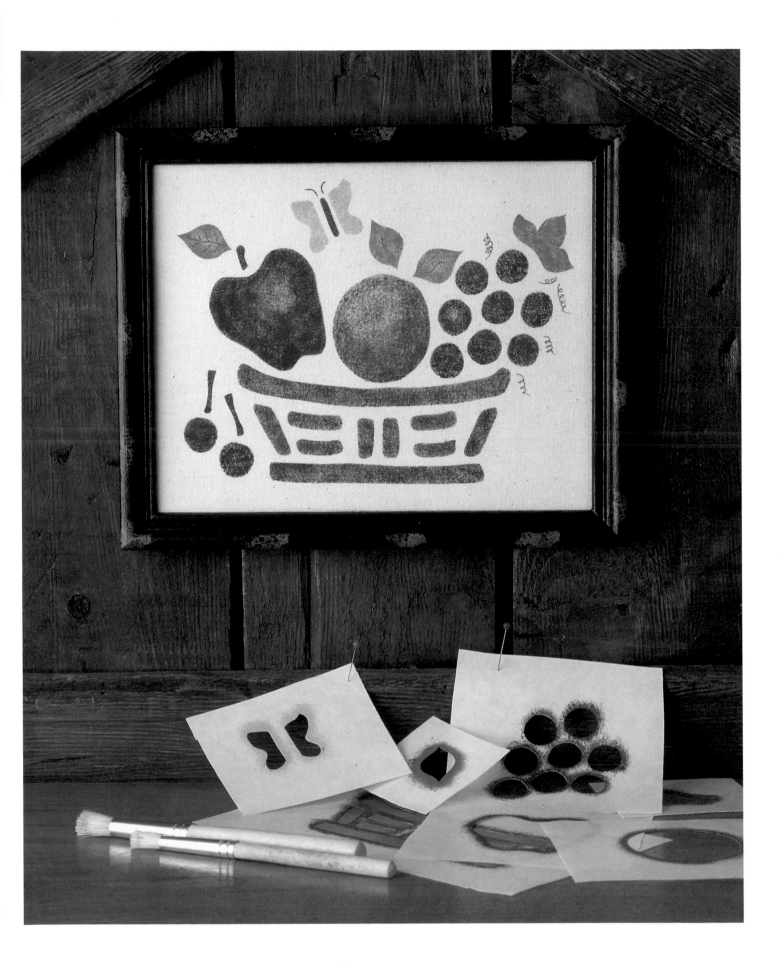

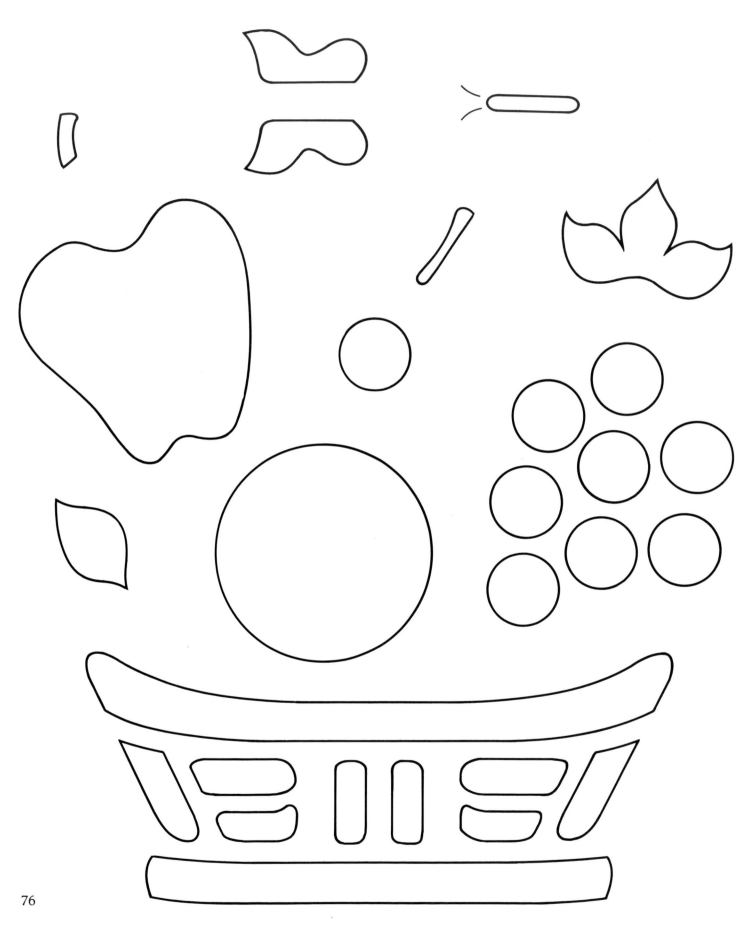

ACTUAL-SIZE PATTERN FOR THEOREM PAINTING

Cross-Stitch Sampler

A sampler is a picture made with needle and thread. You can make perfect cross-stitches by sewing on gingham fabric, using the checks as a guide. Just stitch from corner to corner! You can follow our design or create your own sampler design using the alphabet and numbers shown on this page. For an antique look, you can tea-dye your fabric first, following the directions for the Theorem Painting project (p. 74).

MATERIALS:
piece of ¼"-check gingham (10 × 12" for our design)
heavy-weight fusible interfacing cut same size as gingham
pencil
embroidery floss: black, green, red, blue, brown
embroidery needle (large eye, sharp point)
iron, ironing board

TO BEGIN:
Following the directions that come with the interfacing, bond it to the back of the gingham with the iron. This will keep the fabric firm so that stitches are less likely to pucker.

TO TRANSFER THE DESIGN:
Referring to the pattern and using a pencil, lightly mark the Xs that make each letter, number, and design on the gingham. Count the squares carefully.

TO CROSS-STITCH:
1. Select the first embroidery floss color and cut a piece about 12" long.

2. Look closely at the floss and you will notice it is made up of six strands of thread. Separate the floss into two lengths of three strands each.

3. Thread the needle and make a knot at one end of the floss.

4. Bring the needle up from the back of the fabric into one corner of a pencil-marked square. Bring the needle down through the fabric into the diagonally opposite corner, pulling the thread all the way through.

5. Bring the needle up through the fabric at the third corner of the check and down through the last corner, completing the X.

6. When you are doing a lot of stitches in a row, you can make all the first parts of the Xs, then come back and "cross" them. This can save time when working in one color.

7. Fasten the thread on the back of the fabric and change colors as needed.

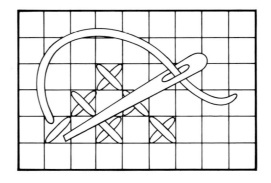

CROSS-STITCH

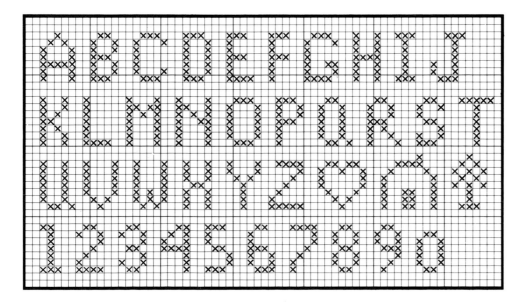

PATTERN FOR SAMPLER

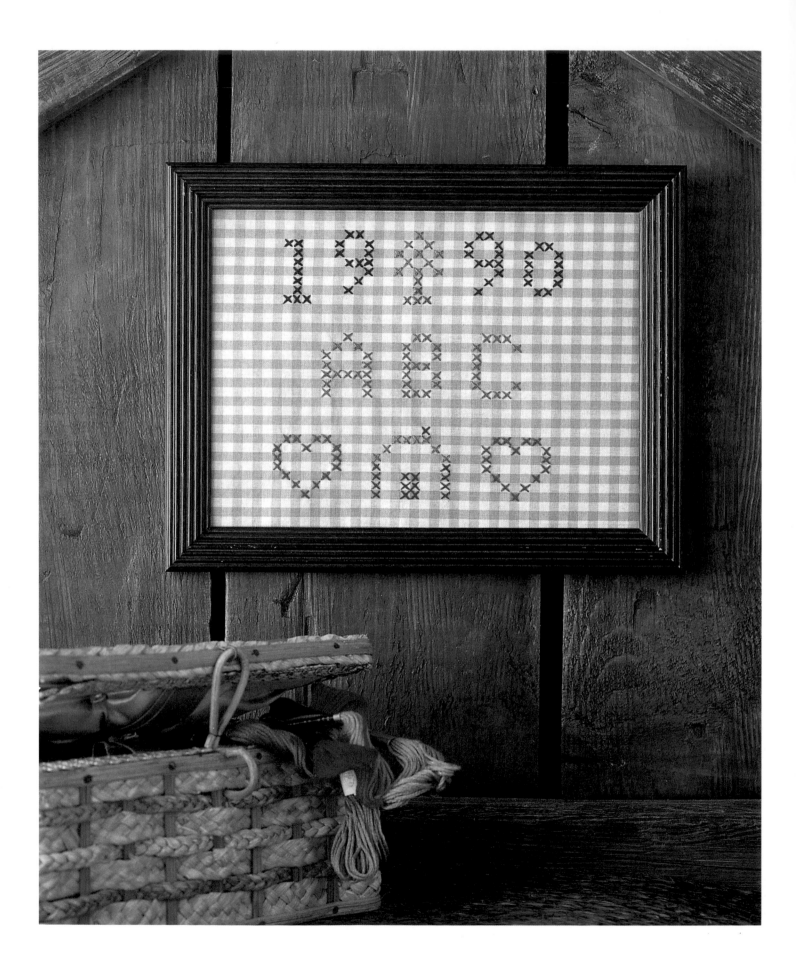

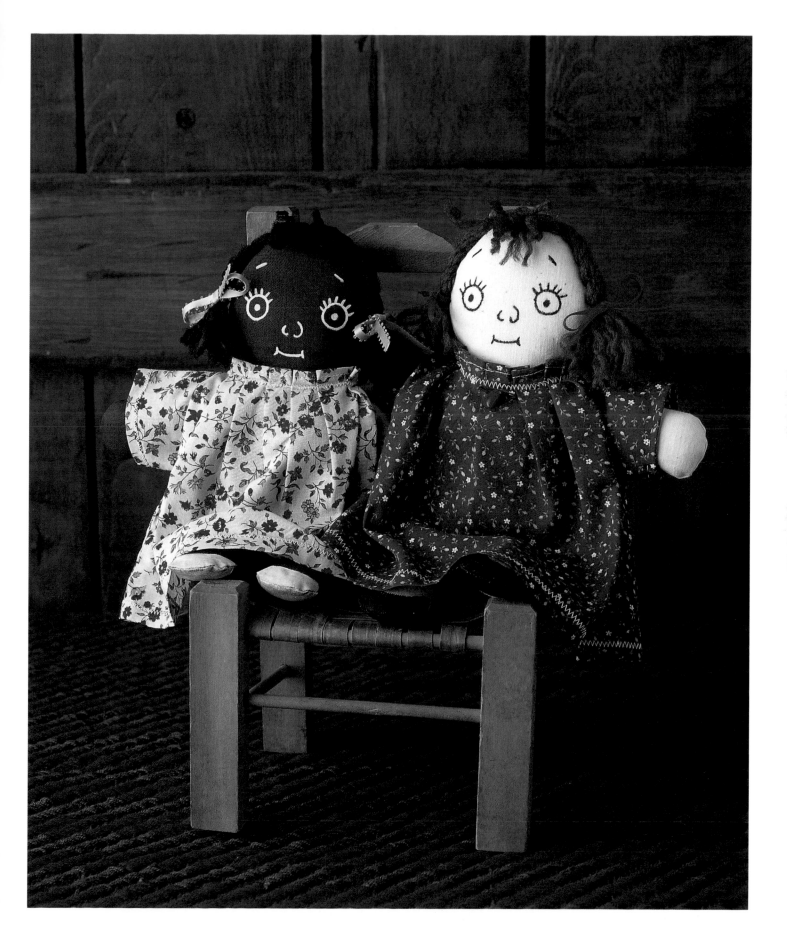

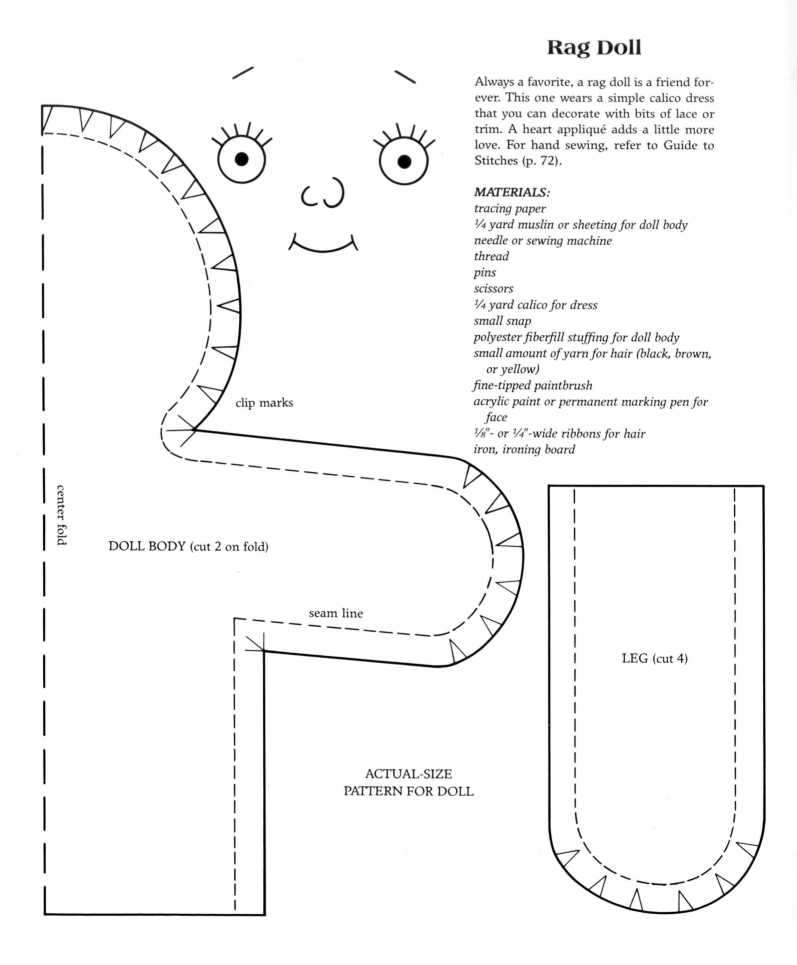

Rag Doll

Always a favorite, a rag doll is a friend forever. This one wears a simple calico dress that you can decorate with bits of lace or trim. A heart appliqué adds a little more love. For hand sewing, refer to Guide to Stitches (p. 72).

MATERIALS:

tracing paper
¼ yard muslin or sheeting for doll body
needle or sewing machine
thread
pins
scissors
¼ yard calico for dress
small snap
polyester fiberfill stuffing for doll body
small amount of yarn for hair (black, brown, or yellow)
fine-tipped paintbrush
acrylic paint or permanent marking pen for face
⅛"- or ¼"-wide ribbons for hair
iron, ironing board

clip marks

center fold

DOLL BODY (cut 2 on fold)

seam line

LEG (cut 4)

ACTUAL-SIZE
PATTERN FOR DOLL

TO BEGIN:

Trace the doll body, leg, and dress patterns onto paper and cut them out.

TO CUT THE DOLL BODY:

1. Fold muslin fabric and place straight side of pattern along fold. Pin pattern to fabric and cut out. Open into one body piece. Cut another piece just like it.

2. Pin pattern to fabric and cut four leg pieces (two pair) from the muslin.

TO MAKE THE DOLL BODY:

1. Pin the two body pieces together around all edges except the bottom.

2. Using backstitch, sew the two body pieces together along seam line, ¼" from the edges.

3. Clip the curved edges of the doll body, making small Vs as shown on the pattern, so that the seams will be smooth along the curves when the body is turned right side out.

4. Turn the body right side out and iron.

5. Trace or draw face on doll head. Paint and let dry.

6. Stuff the doll body with fiberfill, packing head and hand areas firmly. Use a chopstick or the eraser end of a pencil to push filling into small areas.

7. Turn in the bottom edges of the body, pin closed, and sew across, using overcast stitch.

8. Pin the leg pieces together in pairs.

9. Leaving the top edges open, sew around the legs ¼" from the edges.

10. Clip the curved edges; turn right side out and iron.

11. If you wish, paint a shoe on the end of each leg. Let dry.

12. Stuff with fiberfill, turn in the top edges, pin, and sew closed.

13. Sew the legs to the bottom of the body.

TO MAKE THE DOLL'S HAIR:

1. Cut nine strands of yarn, each 12" long.

2. Tie strands together 2–3" from one end.

3. Braid for about 5", tie strands together, then trim excess yarn 2–3" from knot.

4. For bangs, stitch short pieces of yarn to the top of the head along the seam line.

5. Center and pin the braid to the top of the head along the seam; stitch in place.

6. Tie ribbon bows over the knots at each end of the braid.

TO MAKE THE DOLL'S DRESS:

1. Fold the calico in half. Place the long straight side of the pattern along the fold. Pin and cut; this is the dress front. In the same way, pin and cut the dress back. Cut along center fold line from top to bottom of dress back, making two halves.

2. Press sleeve hem edges under ¼" and sew.

3. Place the right sides of the dress back together and pin along the center back (the long straight edge). Sew a ¼" seam from bottom edge up 4", to dot marked on pattern.

4. Iron the seam flat, pressing back the unsewn ¼" seam allowance to the top edge of the dress.

5. Sew the pressed-back seam allowance from one top neck edge to the center back seam and up the other side to the other neck edge.

6. With the right sides of the dress front and back pieces facing each other, pin each shoulder from the neck to the sleeve hems. Also pin the underarm/side seams.

7. Sew all seams ¼" from the edges. Clip the corners as shown on the pattern and iron the seams flat.

8. Press under ¼" along the dress hem edge and sew.

9. Press under ¼" along the neck edge and sew.

10. Try the dress on the doll. To make a fitted neck, pin 7 or 8 small pleats across front neck edge, and 3 or 4 pleats on each side of back neck edge.

11. Take the dress off the doll. Sew across all the pleats.

12. Sew a small snap at top of back opening.

13. Refer to the color photo for some ideas on how to trim the dress.

neck edge

clip

sleeve hem

center fold (front)

seam line for back only

center cut (back)

ACTUAL-SIZE DRESS
(cut 2 on fold)

clip

hem edge

82

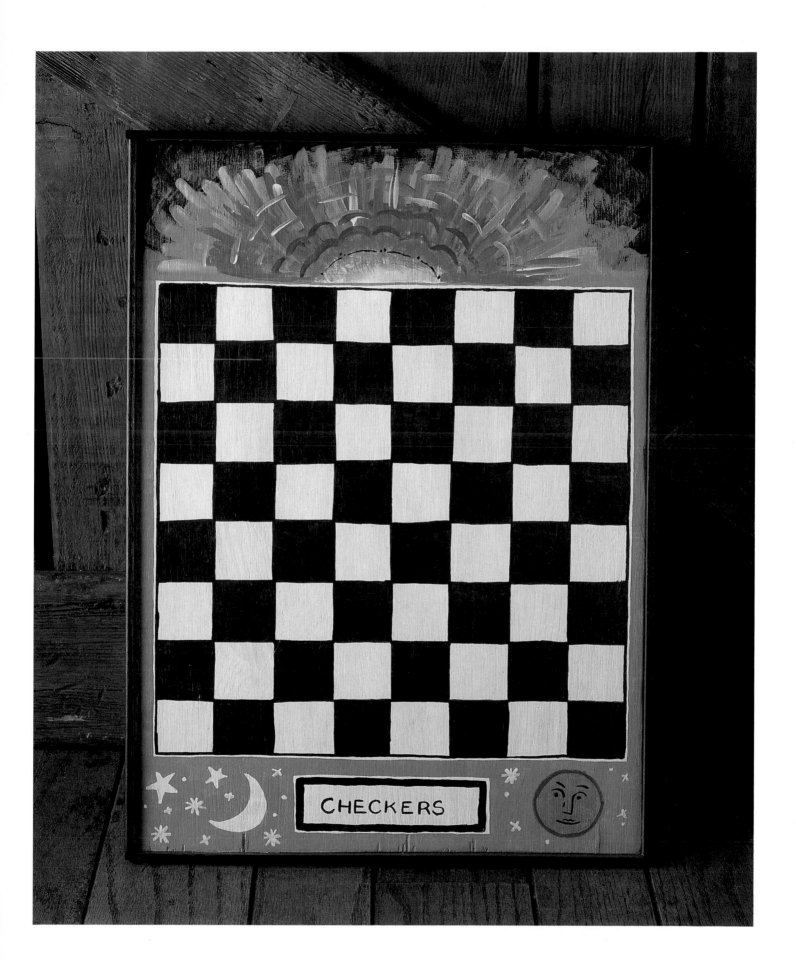

Checkerboard

A checkerboard is not difficult to make; if you don't have wood, you can paint one on a piece of cardboard or heavy paper.

MATERIALS:
¼"-thick plywood or cardboard 13 × 18"
½"-wide strips of shelf edging (simple wood molding), 2 pieces 18" long, 2 pieces 13½" long
small jars or squeeze bottles of acrylic paint: black, white, blue, red, yellow, brown
small jar acrylic primer
sandpaper
hammer
finishing nails
assorted paintbrushes
wood glue
18" ruler (a transparent one ruled in a grid is handy)
pencil
clear acrylic sealer

TO PREPARE THE BOARD:
1. If using wood, sand the board until smooth.
2. Paint the board and edging strips with one coat of primer. Let dry.
3. Paint the back of the board and the inside of the edging strips brown. Let dry.
4. Paint the outside of the edging strips black. Let dry and set aside.
5. Paint the front of the board white. Let dry.

TO MARK THE DESIGN:
1. Following the diagram, use the ruler and pencil to draw a line across the front of the board 3½" down from the top edge.
2. Draw another line across the board 2½" up from the bottom edge.
3. Draw a line ½" in from each side of the board.
4. Measuring 1½" for each square, mark a 12" checkerboard within these four lines.

ACTUAL-SIZE PATTERN FOR MOON

TO PAINT THE DESIGN:
1. Use the design shown here as a guide.
2. With a small brush paint a thin black line over the pencil lines of the checkerboard. Let dry.
3. Paint every other square black. Let dry.
4. Paint the top border area black. Let dry.
5. Paint the bottom and side borders blue. Let dry.
6. Paint the sun design; color the blue part of the design first, next add the yellow, then highlight with the red.
7. With a pencil, lightly mark the design for the bottom border on the board.
8. Paint the rectangular box, the stars, and the crescent moon white.
9. Paint the man-in-the-moon yellow, then edge with a thin line of red.
10. Paint a black border and the word "checkers" in the rectangular box. Paint the man-in-the moon's features black.
11. Let the paint dry completely, then apply a coat of clear acrylic sealer, following the directions on the can.

TO FINISH THE CHECKERBOARD:
Put a thin line of glue along the sides of the board and nail the 18"-long edge strips in place. Then glue and nail the remaining strips to the top and bottom of the board.

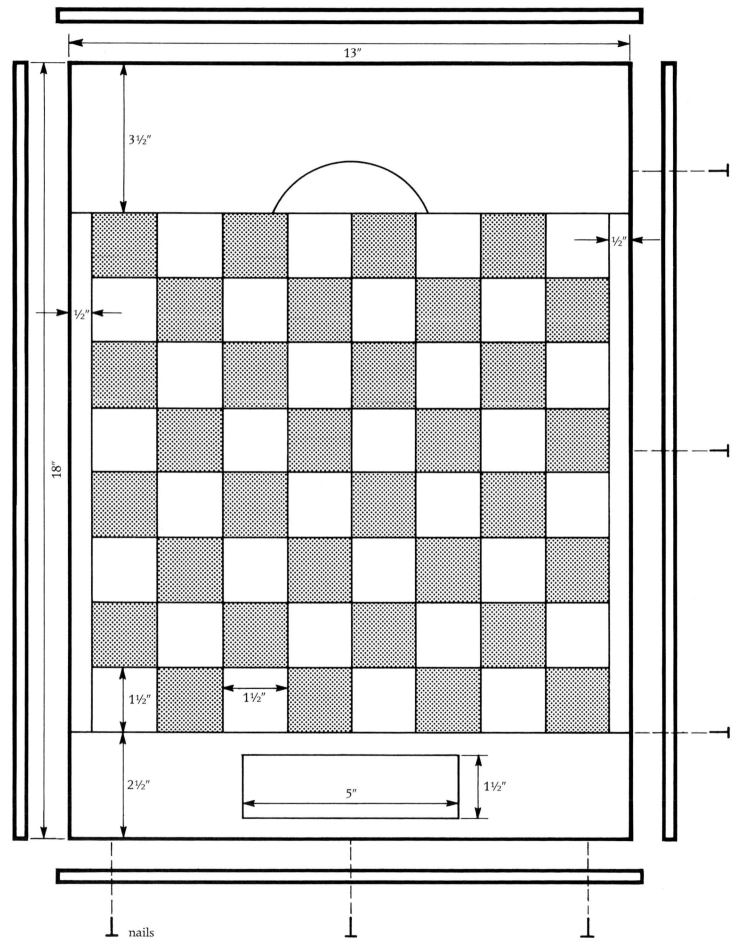

nails

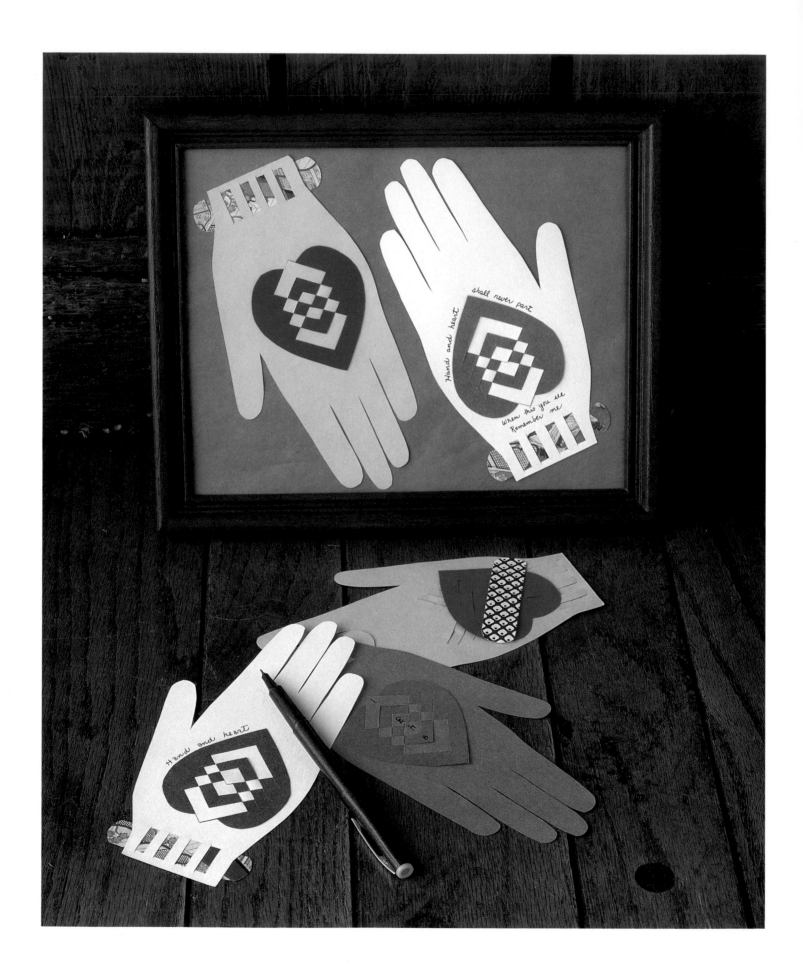

Heart and Hand Valentine

Tokens of love, these simple woven pieces are made from inexpensive construction paper. They are fun to make for Valentine's Day, and you can also use them as place cards for a party or as special thank-you notes any time of the year.

MATERIALS:

construction paper in assorted colors
printed origami paper (optional)
pencil
tracing paper
light-weight cardboard or oaktag
scissors
craft knife, such as an X-acto
fine-point marking pen
white glue

TO MAKE THE HEART AND HAND:

1. Trace the patterns; be sure to trace all the lines drawn inside each shape. Glue the tracings to the cardboard.

2. Using scissors, carefully cut out the cardboard patterns to use as templates. Place a thick layer of newspaper or a cutting mat on your worktable. Using the craft knife, cut V-shaped lines in both hand and heart.

3. For each card you wish to make, place the cardboard hand and heart templates on contrast-colored construction paper and trace around the edges and in the slits with a pencil. Using scissors, cut out each shape.

4. In the same way, cut the wristband shape from origami or construction paper.

5. Place the heart and hand cut-outs on the protected cutting surface. Using the craft knife, carefully cut along the V-shaped lines and the lines in the wrist.

TO WEAVE THE HEART AND HAND TOGETHER:

1. Put the heart on top of the hand with the point toward the fingers. Refer to the pattern and place point D under point 1, C under 2, B under 3, and A under 4. Slide together as far as possible.

2. Weave by pushing point D up from the underside and over point 2, C up and over 3, and B up and over 4.

3. Complete the weave by tucking C under 4 and D under 3.

4. Place the wrist piece under the hand and weave them together, up and down through the slashes.

5. With the fine-point marking pen write this verse around the heart:

Hand and heart shall never part
When this you see
Remember me

ACTUAL-SIZE PATTERN FOR
HEART AND HAND VALENTINE

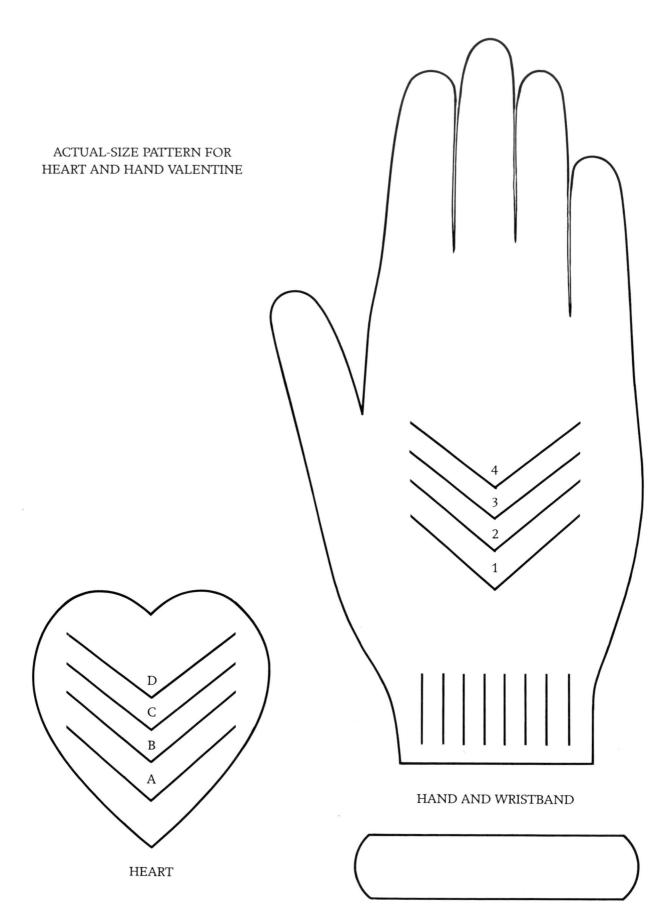

HAND AND WRISTBAND

HEART

Sponge-painted Box

Sponge painting is only one of many techniques used by folk artists to decorate plain surfaces. A simple process, it gives objects a mottled look. Other effects are achieved by other methods: comb-like tools make wavy lines, feathers simulate marble, and stenciling and freehand painting offer a wide range of motifs.

MATERIALS:

wood box or other item (unpainted, or to be repainted)
2 contrast colors of acrylic paint (such as white and blue or red and yellow)
clear acrylic sealer
paintbrush
clean, dry cellulose sponge (kitchen type, 2½ × 3½")
plastic plate
newspaper or paper towels

TO BEGIN:

Cover your worktable with newspapers or paper towels, and do all painting on top of them. First, paint the box with one color. Let dry. Apply a second coat. When dry, box is ready to be sponge-painted.

TO SPONGE-PAINT:

1. Cut a small 1½–2" shape from a dry sponge. A circle, square, or diamond is a good choice.

2. Pour a small amount of the second paint color on the plastic plate.

3. Dip the flat side of the sponge lightly into the paint. Dab onto newspapers or paper towels, removing excess paint until dabbing produces a mottled pattern.

4. Begin to dab the sponge onto the box in an allover pattern. As needed, add more paint to the sponge and dab excess onto the paper covering the worktable.

5. Let dry.

6. Finish with a coat of clear acrylic sealer, following the directions on the can.

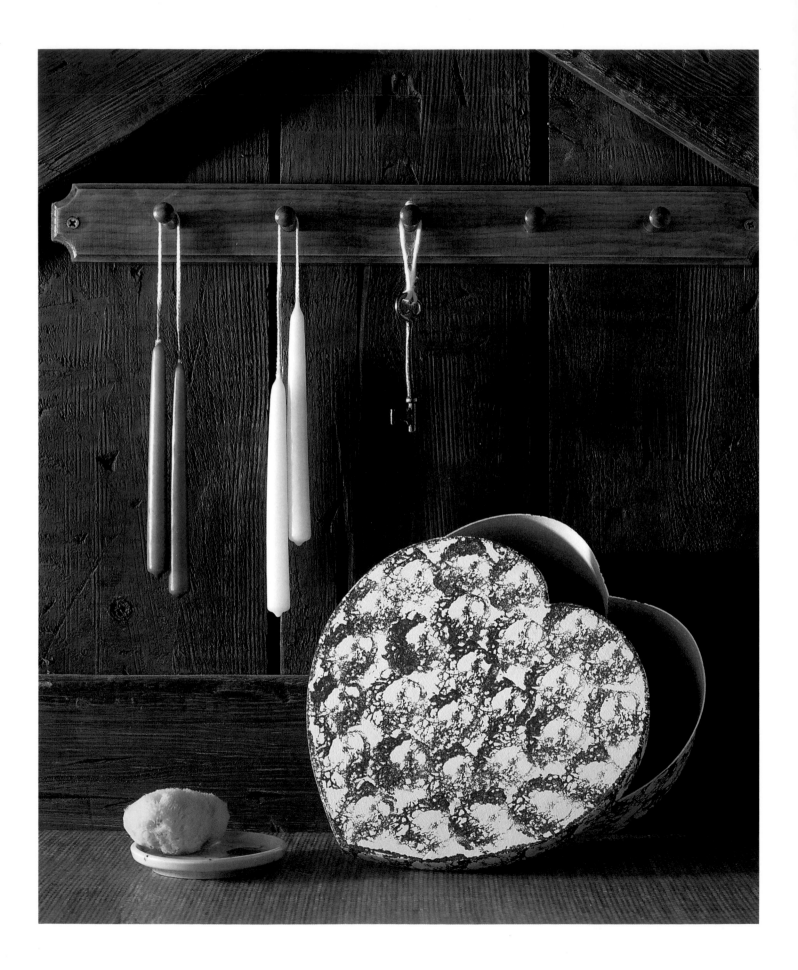

Fraktur

The birth and baptismal certificate is one of the most common examples of fraktur. Leaves, vines, hearts, flowers, and birds were commonly used motifs. To create a fraktur with your birth date on it, follow the design shown here or use the Martin Andres fraktur (p. 52) as a guide.

MATERIALS:

parchment or watercolor paper (white or natural)
2 tea bags
large flat pan
tracing paper
pencil
masking tape
fine-point brown marking pen
clear acrylic spray sealer
acrylic paints: red, yellow, blue, green
plastic plates
assorted paintbrushes

TO TEA-DYE PAPER FOR ANTIQUE LOOK:

1. Steep two tea bags in two cups of hot water.
2. Let cool slightly and pour into a large flat pan.
3. Immerse paper in tea until it turns the desired color. Dry flat on a piece of plain paper or clip to a clothesline.
4. Press the paper when dry to make it smooth.

TO TRANSFER THE DESIGN:

1. Trace the design onto tracing paper, making sure all lines are drawn boldly.
2. Tape the tracing paper to a window-pane. Center and tape the parchment paper over it.
3. Using the pencil, trace the design onto the parchment. Lift the tape off carefully when finished.

TO PAINT THE FRAKTUR:

1. Using the marking pen, draw over all the penciled design lines *except* the straight lines used to mark the spaces for the names.
2. Spray with two light coats of clear acrylic sealer to set the pen lines so they will not run when the design is painted.
3. Put a little acrylic paint of one color on a plastic plate and thin slightly with water. Refer to the illustration and use it as a guide to painting each part of the design. Let dry.
4. In the same way, thin the other colors, one at a time, and paint the rest of the design. Let dry completely.
5. Write in your name, birth date, parents' names, and any other information you wish to include. You may want to pencil in the information lightly before using the marking pen.
6. When finished, spray again with clear acrylic sealer.

ACTUAL-SIZE PATTERN FOR FRAKTUR

Acknowledgments

ANY WONDERFUL FRIENDS AND colleagues at the Museum of American Folk Art have contributed to my enthusiasm for and knowledge of folk art. Most especially I thank Karen Schuster, who for fifteen years has been an energetic, tireless, wise, and compassionate colleague and a treasured friend. For their indomitable efforts in establishing the Museum's first docent program, I thank Lucy Danziger and Susan Klein; this book grew out of that program's Educational Outreach Program to New York City schoolchildren.

To our own children—Sloane, Brooke, Devan, and Megan, Andy and Jeffrey, David and Rebecca, and Hilary—who spent their childhood attending Museum events and lectures, antiquing, and hearing endless Museum conversations, the book is a thank-you for all those times when their patience was tested to the limit. It is my hope that their early discovery of folk art will lastingly enrich their lives.

For generously imparting to me so much of their knowledge and expertise, I thank Bob Bishop, Gerry Wertkin, Edith Weiss, Marie DiManno, and Liz Warren. And for their assistance in putting this book together, I thank Stacy Hollander, Susan Flamm, Mary Ziegler, Ann-Marie Reilly, Lee Kogan, Julia Arliss, Janey Fire, Karla Friedlich, and Phyllis Tepper.

I am indebted to Madeline Guyon for creating the folk art projects, which bring strength and an extra dimension to the book, and to my editors, Lois Brown for bringing the manuscript to life, Ruth Eisenstein for her sensitive, unfaltering, and prodigious editing, and Ellen Rosefsky for her diligence and grace in overseeing the production. Darilyn Lowe I thank for her inspired design.

I thank Robie Rogge for inspiring me, from beginning to end, with her enthusiasm and ideas, and by her own extraordinary creativity. To Hilary's friends Jordan, Caroline, Nora, Susannah, Allison, Hannah, Andrew, Danielle, and Philippe: thank you for helping me to see folk art through your eyes. My deepest appreciation goes to my husband, Bob, our daughter, Hilary, and my parents, James and Abigail Van Allen, with whom and for whom all things are possible.

C. V. A. S.

EEP APPRECIATION AND THANKS to Bob Bishop for including me in this innovative project; to Roberta, Wayne, Dianne, and Susan Drake for graciously arranging many supply outings; to my parents, especially my mother, who, besides needlework, always has a paintbrush and pliers handy; to Barbara and Leigh, my day-to-day fans. And all my love to Bill.

Special thanks for materials to Priscilla Miller, Concord Fabrics; Robin Steele, V.I.P. Fabrics; Jane Schenck, Pellon Sales Corp.; H. D. Wilbanks, Hobbs Bonded Fibers; and the E. Islip Lumber Co.

M. H. G.

Further Reading

An American Sampler: Folk Art from the Shelburne Museum (exh. cat.). Washington, D.C.: National Gallery of Art, 1987.

Andrews, Ruth, ed. *How to Know American Folk Art.* New York: E. P. Dutton, 1977.

Bishop, Robert. *American Folk Sculpture.* New York: E. P. Dutton, 1974.

Bishop, Robert, and Patricia Coblentz. *A Gallery of American Weathervanes and Whirligigs.* New York: E. P. Dutton, 1981.

Black, Mary, and Jean Lipman. *American Folk Painting.* New York: Clarkson N. Potter, 1966.

Hemphill, Herbert W., Jr., and Julia Weissman. *Twentieth-Century American Folk Art and Artists.* New York: E. P. Dutton, 1974.

Levie, Eleanor. *Great Little Quilts: 45 Antique Crib and Doll-size Quilts with Patterns and Directions.* New York: Harry N. Abrams, Inc., 1990.

Lipman, Jean, and Tom Armstrong, eds. *American Folk Painters of Three Centuries.* New York: Hudson Hills Press, Inc., in association with the Whitney Museum of American Art, 1980.

Lipman, Jean, Robert Bishop, Elizabeth V. Warren, and Sharon L. Eisenstat. *Five Star Folk Art: One Hundred American Masterpieces.* New York: Harry N. Abrams, Inc., in association with the Museum of American Folk Art, 1990.

Lipman, Jean, Elizabeth V. Warren, and Robert Bishop. *Young America: A Folk-Art History.* New York: Hudson Hills Press, Inc., in association with the Museum of American Folk Art, 1986.

Lipman, Jean, and Alice Winchester. *The Flowering of American Folk Art (1776–1876).* New York: Viking Press, 1974.

Richards, Caroline Cowles. *Village Life in America: 1852–1872. As Told in the Diary of a School Girl.* Williamstown, Mass.: Corner House Publishers, 1972.

Safford, Carleton L., and Robert Bishop. *American Quilts and Coverlets.* New York: E. P. Dutton, 1972.

Schaffner, Cynthia V. A., and Susan Klein. *Folk Hearts: The Heart Motif in American Folk Art.* New York: Alfred A. Knopf, 1984.

Sterbenz, Carol E. *American Country Folk Crafts: 50 Country Craft Projects for Decorating Your Home.* New York: Harry N. Abrams, Inc., 1987.

Warren, Elizabeth V., and Stacy C. Hollander. *Expressions of a New Spirit: Highlights from the Permanent Collection of the Museum of American Folk Art* (exh. cat.). New York: Museum of American Folk Art, 1989.

Index